Published by
Kulturstiftung Basel H. Geiger
& Hatje Cantz

ONE MONTH AFTER BEING KNOWN IN THAT ISLAND

Caribbean Art Today

HATJE
CANTZ

Contents

Basel Welcomes the Caribbean
Raphael Suter, Director, Kulturstiftung Basel H. Geiger

Though the connection between the city of Basel and the Caribbean may not be obvious at first glance, those of us at the cultural foundation Kulturstiftung Basel H. Geiger—otherwise known as KBH.G—have decided it makes perfect sense to kick off our exhibition activities in this German-speaking, France-adjacent Swiss city with a group show devoted to contemporary Caribbean art.

The KBH.G was founded in 2018 with the goal of providing Basel and its inhabitants with a unique forum for art and artistic production—a space both architecturally and intellectually free, where it would be possible to stage exhibitions that do not observe the established boundaries that define existing institutions. In fulfilling those aims, one of the most important priorities for benefactors Sibylle Piermattei Geiger and Rocco Piermattei is to create a cultural platform in which each new exhibition speaks to people and invites them to enjoy a completely different kind of art experience, unconditionally free of charge. In this regard, Basel and the Caribbean are a perfect match. That is why the KBH.G has chosen to inaugurate its new platform by collaborating with the Caribbean Art Initiative to build a bridge between different countries, artists, dialogues, and peoples.

And it is at the KBH.G that the Caribbean Art Initiative—which grew out of a program started by a Basel-based company specializing in the production of luxury cigars and is now supported by an association headed by Albertine Kopp, the initiative's intrepid director since its inception—will stage the first-ever group exhibition of Caribbean artists in Switzerland.

With the Caribbean Art Initiative and its two visionary curators, Yina Jiménez Suriel and Pablo Guardiola, the KBH.G has found the ideal partners with whom to officially inaugurate its Basel space. The exhibition, entitled *One month after being known in that island*, will be the first of an ongoing series of different KBH.G exhibitions highlighting a variety of artistic fields.

As a new foundation, the KBH.G intends to complement Basel's many excellent museums, exhibition spaces, and commercial galleries—not to compete with them. Our aim is to help expand the city's already impressive cultural offerings. We are convinced that Basel, with its two hundred thousand intellectually curious and culturally interested residents, as well as its many astute visitors, will appreciate the richness of this offering. For all of these reasons, we are thrilled that with this inaugural show—and with upcoming exhibitions—we will have the opportunity to add to the cultural diversity our city has to offer.

Art as an Engine of Cultural Identity
Albertine Kopp, Founder and Director,
Caribbean Art Initiative

The Basel-based Caribbean Art Initiative's mission
is to champion contemporary art with ties to the
Caribbean. Usually we do this by sponsoring inter-
national artists to spend time in the Caribbean,
and Caribbean artists to spend time away from the
region in residencies abroad. Now, my home-
town of Basel will be the site of our first large-scale
exhibition of contemporary Caribbean art.

Ties between the Caribbean and Basel date back
to the summer of 1795. That is when represen-
tatives of Europe's great powers—Prussia, Spain,
and the French Republic—gathered in the Swiss
city to establish the framework of the Peace of Basel
treaties. The Basel accords officially ended the
War of the First Coalition, which the European
powers had led against revolutionary France. They
also reallocated several Caribbean colonies, in-
cluding the West Indies region, which Columbus had
"discovered" on his first voyage to the "New World."

While Europe certainly controlled the colonies
in the eighteenth century and beyond, the fate
of certain territories was partly decided by the local
response. During the French Revolution, for
example, freed former slave and Haitian general
Toussaint Louverture succeeded in leading Haiti

to independence. And on January 1, 1804—after years of civil war, a temporary reintroduction of slavery, English blockades, and a severe yellow-fever epidemic—Jean-Jacques Dessalines, the governor-general of Haiti, declared Saint Domingue independent and Haiti the world's first free black state. In the following years, the Spanish part of the island would again be separated from the French. And by 1844, the Dominican Republic would finally—aside from short periods of Spanish and American occupations—attain independence.

The turbulent history of Caribbean colonization left deep scars that are still evident today. For example, both French and Spanish are spoken on the island of Hispaniola, with Creole being the official and vernacular language of Haiti and other islands. Yet all attempts to realize Édouard Glissant's idea of creating unity through the Creolization of Caribbean culture and politics have yet to come to fruition. Also, there is no *Antillanité* (Antillean identity) based on nationality or language, something keenly perceived by artists who aspire to create a new identity for the archipelago by working with colors, forms, materials, images, and experiences, rather than language.

We at the Caribbean Art Initiative use the term *Caribbean* primarily in a geographical sense. We do so in hopes of overcoming local frictions that still exist between various political systems, languages,

and cultural traditions. We aim to allow artists to meet with one another on neutral territory to exchange ideas about a shared Caribbean identity, one that has both an inward and outward effect. This neutral platform is a meeting point for artists from diverse cultural traditions. Its goal is not to foster the creation of something homogeneous, but to encourage the expression of a multifaceted identity.

This exhibition—the first public presentation in Switzerland of a broad spectrum of art being produced in the Caribbean—is guided by the same aspirations. Curators Yina Jiménez Suriel, from the Dominican Republic, and Pablo Guardiola, from Puerto Rico, have assembled a group of artists who grapple with questions of Caribbean history, identity, and culture. Their selected works pose different ways of thinking about inhabiting, reading, and communicating the Caribbean. Thus, the show can be seen as an invitation for viewers to participate in a dialogue that opens up new perspectives.

We are not pleading the case for Caribbean culture and art. Nor are we searching for some kind of lost history. Our focus is on supporting a new generation of contemporary artists in order to broadcast what they have to say. Lack of state support has drained much of the region's cultural potential. And sadly, its colonial past continues to promote

the fractured nature of the region's present. Funding from abroad is rare and, when offered, often limited in scope.

The Caribbean Art Initiative is a point of contact for individuals, companies, foundations, and endowment funds that are interested in the region and want to actively engage in supporting it. We endeavor to bring all stakeholders together to promote a shared, long-term, and strategically stable culture for the region without imposing any outside agenda on it.

Therefore, we are especially glad that with the generous financial support of the KBH.G we are able to offer an international platform for Caribbean artists, and broad public access to the artistic production of an extremely dynamic region. Although it is just one step among many needed, this exhibition is an important advance toward international recognition of the work and voices of Caribbean artists.

WAYS OF WORKING

YINA JIMÉNEZ SURIEL AND PABLO GUARDIOLA

One month after being known in that island is a project based on a group of artists working in and from the Caribbean region. In view of the location of our exhibition, in Basel, Switzerland, our point of departure is the Treaty of Basel, an eighteenth-century peace agreement between colonial powers that recast the status of Caribbean territories. As curators who were born, raised, and work in the Caribbean, we approach this treaty not only as a historical artifact but also as a literary work, since its creation was so steeped in speculation.

Ratified on July 22, 1795, and comprising seventeen articles, the Treaty of Basel formally ended the two-year War of the Pyrénées between the First French Republic and the Spanish monarchy. It restored to Spain the northern provinces taken by France in exchange for granting France the eastern two-thirds of what was then Hispaniola, the second largest island in the Greater Antilles. While the pact was settled in the neutral city of Basel, to resolve a territorial conflict between two European countries on European soil, its terms—as elaborated in Article Nine—involved realigning colonial territory in the Caribbean. For the signatory powers, the geographic location of those territories was so remote that all decisions about their fate were made solely on the basis of an imaginary context. The anti-slavery Haitian Revolution, which began four years prior to the Treaty in 1791 by self-liberated former slaves in opposition to French colonial control, was intentionally ignored. In hindsight, the achievements of that uprising should have nullified the treaty's ninth article:

IX. In exchange for the restitution referred to in Article IV ["The French Republic restores to the King of Spain all the conquests it has made in its States during the current war"], the King of Spain by himself and his successors, yields, and abandons the whole Spanish part of the Island of Santo Domingo in the West Indies in all property to the French Republic.

One month after being known in that island, the ratification of this treaty will allow the Spanish Troops to be ready to evacuate the squares, ports, and establishments they occupy there to deliver to the French troops when they appear to take possession of it.

The squares, ports, and establishments referred to will be given to the French Republic with the exiting cannons, war munitions, and significant effects to their defense when this agreement in known in Santo Domingo.

The inhabitants of the Spanish part of Santo Domingo, who, for their interests or other reasons, prefer to transfer themselves along with their property to the possessions of S. M. Católica, may do so within the space of one year from the date of this agreement.[1]

At the time, of course, the Haitian insurrection was not factored into the European edicts. From a contemporary perspective, however, the article's obvious historical futility has symbolic value. Reality as imagined from a position of power is one thing. Reality as perceived by those who suffer the consequences is quite another.

The colonial structures established through international settlements—the Treaty of Basel being just one of many—reconfigured both the cartography of the Caribbean archipelago and the system of relations between local communities and territories. Such settlements may be considered blueprints for European and American colonial perspectives on the Caribbean. Although technically legal, these documents created, modified, or outright destroyed local realities. From Tordesillas in 1494 to Concordia in 1648 to Ryswick in 1697 to Aranjuez in 1777, and all decisions made by the United States Office of Insular Affairs from 1898 onward, countless examples confirm this.

For almost three centuries, the Caribbean was the world's largest region under colonial control. Spain, France, Holland, and England snatched up territories during the seventeenth and eighteenth centuries. In the nineteenth century, the United States of America joined in the fray. In the twentieth century, a long list of foreign interventions, primarily conducted by the U.S.A., continued to besiege the already fractured region. Nowadays, a different kind of control over large swaths of the Caribbean is exerted largely by foreign investors who rarely consider the local population when making deals that aggressively alter the socioeconomic landscape.

The legacy of colonization has left the region with a wide array of political structures. Some islands are still officially controlled by distant states. Martinique and Guadeloupe are

YINA JIMÉNEZ SURIEL AND PABLO GUARDIOLA

departments of France, Curaçao and Aruba are constituent countries of the Kingdom of the Netherlands, Anguilla and the Caymans belong to the United Kingdom, and the United States controls Puerto Rico and the U.S. Virgin Islands. And that's not even the whole list. Some are legally independent but actually controlled by other governments. Some have gained independence—with varying degrees (and definitions) of success—after longer or shorter periods of foreign rule. Drastic differences in self-determination status have endowed the archipelago with a fractured concept of sovereignty that, to this day, involves deep ambiguities. Different peoples in the region embrace its complexity and take ownership of its multiple meanings in their own particular ways.

For this project, we aspire to what Barbadian writer George Lamming calls sovereignty of the imagination, which he described in a 2002 interview as "the free definition and articulation of the collective self, whatever the rigor of external constraints." As part of our quest for freedom, we believe that articulating strategies for different ways of functioning than those imposed by colonial or economic order is essential in order to authentically live, sense, and work in the eclectic Caribbean present. Hence, our sense of sovereignty is and will always be irreverent at its core.

There are countless examples of Caribbean people taking alternative approaches to nourishment, consumption, conviviality, domesticity, and working. Imagining other ways of living enables us to narrate our stories and to define our relationships with history and nature, which is the basis for the intellectual, aesthetic, and political production of our latitudes. For us, the production of thought needs to be an exercise in freedom—one in which we connect all the dots that were never supposed to be connected while using our multiple traditions simultaneously.

AN ELASTIC EXPERIENCE

After five-hundred-plus years of colonial rule, it is no wonder that the Greater Caribbean remains a fragmented affair. While the colonial imagination conceived the Atlantic mainly as a means of transporting products and people, the Caribbean Sea amounted to a kind of negative space in which little

internal communication was deemed necessary. Even today, it is easier for tourists to move around the islands using routes available for cruise ships than it is for locals using accessible means of transportation.

But despite the geographical and cultural fragmentation, multiple expressions of particular and powerful cultures have flourished in the Caribbean. What connects us is an always flexible and flowing idiosyncrasy that incorporates numerous histories and multiple points of view. The particular way we inhabit time in the Caribbean is one such point of connection. It is hardly a uniform construct. Caribbean time is a composite of multiple layers and factors, its fluctuation best apprehended through the weather. It can be said that the region only has one prolonged season, since temperatures rarely drop or rise dramatically. On the other hand, one can say there are two seasons—wet and dry. Yet within the wet season, there is the hurricane season when a storm can alter the whole configuration of the land, and all human activity, in a matter of hours. Weather changes in the course of a single day can be quite drastic. A sunny morning can take a radical turn into torrential rain. Then, in a matter of hours, a radiant sun may reappear, making a single day seem like many.

The Caribbean's elastic experience of time pertains to history, too. Present and past paradigms coincide, collide, and coexist in the same unpredictable way that our rural areas, beaches, and densely populated urban centers abut one another—which is to say, in all possible, and even some seemingly impossible, configurations. This historical multiplicity manifests in political realities, too. Certain areas of the region, as mentioned above, still function under de facto colonial rule. Others are run on neocolonial or neoliberal rationales. Still others aspire to redefine their status. Any attempt to comprehend the Caribbean and the ways of working and inhabiting it must therefore acknowledge that parallel times have always coexisted here—not just temporally, but conceptually.

It is from this compound perspective that we perceive the Caribbean. We work with traces that are not explained, but are evident everywhere, as long as we pay close attention. These are traces of distant history, of the recent past, of our day-to-day life. They are what we gaze at, what we experience, what we embrace.

YINA JIMÉNEZ SURIEL AND PABLO GUARDIOLA

Curatorially, we approach this project in the spirit of *Créolité* as conceived by Caribbean writers Édouard Glissant and Kamau Brathwaite. The term has had various interpretations over the years by various thinkers. For us, as for Glissant and Brathwaite, *Créolité* connotes a forward-looking embrace of diversity and the development of relationships with all kinds of people, ideas, and aspects of nature regardless of linguistic and national impediments. We choose this version of the concept as a conceptual framework for our working process. We use it as needed to break out of imposed or inherited cultural forms and patterns, and to create different mindsets, modes of being, and ways of engaging everydayness.

A FLUID IDIOSYNCRASY

Recently, there has been new historical and archaeological research, such as the work of Reniel Rodríguez Ramos in Puerto Rico, that points to evidence of sophisticated exchanges and relations in the region prior to European colonization. Clearly, there is a need for deeper investigations into the history of long-distance interactions in the Greater Caribbean.

One month after being known in that island is meant to be the beginning of a new long-distance dialogue between a group of visual artists and thinkers working in the region and its diaspora. It is our attempt to make visible the different ways Caribbean artists and cultural workers have, little by little, been creating and thinking from this region. For us, this project has intentionally been an exercise in zigzagging—and that is a political standpoint.

The titular phrase, *one month after being known in that island,* comes from the Treaty of Basel's aforementioned ninth article, which describes the French and Spanish governments' intentions vis-à-vis the Caribbean territories. Symbolically, the phrase is meaningful to us because those intentions were not only never accepted by the people in those territories, they were not even actually implemented by the French, who, caught up in other expensive battles, didn't have the resources to see to their enforcement. Isolated from the context of the treaty, this phrase's meaning collapses into utter speculation. While it seems to be describing a linear time,

it does not have a clear point of departure. It appears to reference a territory but locates nowhere specific. It does not identify the people to whom it implicitly refers, nor does it explain what "should be known." We chose this phrase as our starting point since it represents what we want the world to know about our region—that all of us who live in this context have the capacity and ability to reinvent ourselves as much as circumstances require.

Many of the artists included in this project work both individually and collectively. All of them have practices that are fluid and flexible. The works we assembled for this project do not illustrate straight answers to the questions raised by our curatorial statement. On the contrary, we have consciously selected them in order to make people pause and think about what they might mean, what their creators might be expressing, and what kind of capacity we might have or develop to inhabit *Créolité* and the syncretic in a genuinely internalized way.

Elisa Bergel Melo, Minia Biabiany, Christopher Cozier, Tony Cruz Pabón, Sharelly Emanuelson, Nelson Fory Ferreira, Madeline Jiménez Santil, Tessa Mars, Ramón Miranda Beltrán, José Morbán, and Guy Régis Jr. are the participating artists. An interview with each is included in this publication. As people born and residing in Aruba, Colombia, Curaçao, the Dominican Republic, Guadeloupe, Haiti, Puerto Rico, Trinidad and Tobago, and Venezuela, these artists advance different ways of thinking, inhabiting, reading, and communicating the Caribbean. In pointing out the frameworks from which the region's multiple local realities can be approached, their pieces address issues of autonomy, emancipation, and resistance. In intersecting with—or running parallel to—such power dynamics, they confirm the complexities and the possibilities of our region's context.

Two writers, both of whom have grappled with certain Caribbean realities in their literature, are also featured in this publication. In Dominican novelist Rita Indiana's 2015 novel, *La Mucama de Ominculé* (*Tentacle*), one character asks himself, "Do I have two bodies or is it that my mind has the capacity of broadcasting in two channels of simultaneous programming?" The Puerto Rican author Marta Aponte Alsina seems to answer that question in her 2015 essay compilation, *Somos Islas* (*We Are Islands*), when she says,

"We were never pure, but creatures of the transplant, grafting, and bricolage, and maybe that is why we exist." Here, Aponte Alsina reviews strategies developed by people from the region in order to maintain memories and collective histories in the present, while Indiana addresses the problems of maritime frontiers, specifically how the "legalization" of the sea has, since the beginning of the European colonization, been the chief obstacle to circulation.

Contrary to the negative-space approach, *One month after being known in that island* proposes the Caribbean Sea and the region in general as a binding agent. Like a memory from the future, it offers a glimpse of the Caribbean's shared idiosyncrasy, where everyday experiences and historical time are always liquid, and sovereignty may be self-defined. Currently, exchanges between visual artists in the region remain quite limited. In the middle of the previous century, there was a fairly healthy dialogue among writers in the region. But music was the great cultural connector—and, as such, it has been among the most important traces for us as a guide. For this project, we have summoned the twentieth-century spirits of Caribbean literature and music with the aim of supporting a similarly direct and organic network of relations among visual artists and thinkers working today.

1 De Clercq, Alexandre Jean H. *Recueil des Traités de la France depuis 1713 jusqu'à jours (French Treaties From 1713 to Today)*, 23 Bde., Paris 1864–1917, p. 231–232 ff. digitalized, p. 245 ss.; excerpt translated by Yina Jiménez Suriel and Pablo Guardiola

THE POCKET
OF A MIGRANT

MARTA
APONTE ALSINA

In one engraving from Puerto Rican artist José Alicea's 1970 *Baquiné* series, which is named for the ceremony in which parents bid farewell to their dead children, the heads of a grief-stricken mother and her deceased child are rendered against an indeterminate background. That inaccessible space behind the mourner evokes her lack of belonging—her circumstance is so awful and unnatural that, unlike with *widow* or *orphan*, no term even exists for it. The composition suggests not just that she is suffering, but that her pain has put her in a barren place where humanity no longer has meaningful context and forgetfulness takes over the senses—but where, even so, life carries on.

As part of a multi-piece sequence, this work evokes the particular material circumstances of the Caribbean: the class, race, and gender inequalities; the violence and poverty; the causes and social consequences of natural disasters. Wrenching as they are, these conditions confront the viewer with the question of whether it is possible, in the face of such disorder, to recover the threads of memory, and with them a return to meaning. Where are the accumulated material, the protected wisdom, the writing, and the cultural habitus that enable a return to ordinary time after disaster? Or is the question really whether return is possible?

Since the fifteenth century, the Caribbean has been a space of wealth accumulation and tax havens. Colonized by no fewer than five European imperial nations, plus the United States of America, its resources have given rise to major world powers, but nearly always at its own expense. In W.G. Sebald's 1995 novel *The Rings of Saturn*, the narrator recounts a conversation he has with a Dutchman in which the relationship between sugar production in the Caribbean and art history is made clear:

> *It was Cornelis de Jong who drew my attention to the fact that many important museums, such as the Mauritshuis in The Hague or the Tate Gallery in London, were originally endowed by the sugar dynasties or were in some other way connected with the sugar trade. The capital amassed in the eighteenth and nineteenth centuries through various forms of slave economy is still in circulation, said de Jong, still bearing interest, increasing many times over and continually burgeoning anew.*[1]

What this passage reveals is that objects stored in first-world museums and private collections are directly related to the enormous wealth of those who made their fortunes as landowners, slaveholders, and sugar traders. For the bodies of working men and women, cultural accumulation took other forms.

How is it possible, then, for "natives" to think and create "authentically" from a chain of islands occupied by remote economic, cultural, and political interests? In what ways can the meaning of a cultural legacy formed in a colonial situation be interpreted? The broad and diverse insular Caribbean has had many creators, thinkers, and emblems. There is the natural man of Cuban poet and philosopher José Martí; the unstable archive of a chaotic history as described by the Martinique-born literary critic and narrator Édouard Glissant; the relationship between spoken, ancestral languages and the poetic construction of a culture proposed by Barbadian poet Kamau Brathwaite; the Creolité manifesto launched by novelist Patrick Chamoiseau and other intellectuals, proposing a Caribbean consciousness based on self-knowledge and the acceptance of hybrid cultures forever evolving as do regional languages, both Creole and patois; the criticism of the epistemology of Occidentalism and its colonizing scars by Martinique psychiatrist and political philosopher Frantz Fanon and Jamaican novelist and philosopher Sylvia Wynter; the transcultural, archetypal, and animist visions of Guyanese writer Wilson Harris; the repeating islands of Cuban author Antonio Benítez Rojo. And, perhaps most notoriously, the flow of documents, books, and objects that Arturo Alfonso Schomburg—the Puerto Rican author and bibliophile whose mother was born on the Caribbean island of St. Croix—first deposited in New York City's Harlem in 1925.

The Schomburg Center for Research in Black Culture was one of several personal archives established for the purpose of illustrating long-lasting historical processes from the viewpoint of the cultural crossroads of the twentieth century. The archive's founding was not justified by the retrospective views of the twentieth century's European intellectuals, who endeavored to understand the past by collecting and interpreting its fragments. Neither was it an elegy to dominant cultures in crisis. Rather, with little support and few traditional

MARTA APONTE ALSINA

references, the Schomburg Center was intended to collect and represent the cultural expressions of peoples with African roots so that communities worldwide could come to know their perspective. These were poorly documented cultures, peoples who had been plundered and recontextualized as emblems of primitivism by northern collectors and anthropologists. The Schomburg collection was first conceived and managed by self-taught amateur researchers and academically trained intellectuals who were eager to establish a genealogy of their own. A century after its inception, the archive links Caribbean, Latin American, and European countries with African cultures. Like the emptiness against which *Baquiné* plays out, the Schomberg Center's passion to resurrect the unknown dead in order to inform the unknowable future took form with no antecedents and yet succeeded in constructing new narratives.

The migration routes taken by Caribbean families cover global and regional territories. Moreover, people came into the region from far and wide, bringing with them their cultures or origin. As critic Frank Birbalsingh—who was born in Guyana when it was still a British colony—commented in a 2019 interview, these routes evoke an archive of loose leaves and certain "diasporic" methodologies and epistemologies.[2] The smallness, political isolation, and migratory movements of the islands gave rise to complex, fragmented literary cultures. Among the issues examined in contemporary Caribbean literature are the need for a new relationship between human beings and nature; the reparation of memory and the healing of trauma; the liberation from linear, historical time in writings that evoke ceremonies and rituals; the situation of women in the identity complex of race, gender, and reproductive practices formulated in slavery and servitude; self-writing as a rewriting of other cultures and the writing of connecting histories; and writing as a record of oral traditions. Like all literary machines, the literatures of small islands have created new meanings as well as parallel worlds. They have described familiar spaces and imagined escape routes.

Similarly, many Caribbean visual artists have devoted their efforts to exploring memory and archives as they wrestle with the same issues and themes. Some artists engage in the practice of "mining" ruins—places where

modernity and neoliberal globalization have left emptiness and debris. Others appropriate ancestral experiences and transform them. Still others engage the question of how to articulate and protect the existence of non-traditional or -dominant subjectivities. They do so by using multiple media—videos, murals, performances, photography, installations, workshops, and combinations of all these—to communicate the myriad displacements, each of which is unique in some way.

In addition to the recovery and decontextualizing of objects, Caribbean artists use their bodies in their creative processes to explore non-European theoretical frameworks. "Liquid" readings and writings, which overflow customary senses, generate enriching connections. These actions seek to transcend restricted, solid, political, and cultural divisions between countries. In an obdurate manner, Caribbean artists persist in superseding the clichés of colonial education. They wonder how to continue thinking and acting in a situation referred to by poet Derek Walcott, the St. Lucian Nobel laureate, as "the oceanic sadness of history." Young artists share values with their peers globally. Yet, inevitably, they also act on their instinct to follow the Schomburg formula of filling in the gaps around figures that, like the mother and child in Alicea's *Baquiné*, could have been forgotten on the underside of Western history.

Of course, being "invisible" is not always a liability. As Édouard Glissant wrote, "[o]pacity is an epistemological notion that gives everyone the right to maintain, and protect their thick shadow, that is, their particular psycho-cultural thickness.... Opacity thus understood recognizes the existence in each individual of cultural facts incomprehensible to other individuals who are not part of the same culture. The concept reduces legitimacy to the sciences conceived as universal from an ineffective and unreal self-legitimization."[3]

Arts and artists have long sought to create meanings by revealing unusual connections between diverse and distant phenomena. But that which cannot be totally apprehended, understood, and translated may also be a creative force. Under the protection of stealth and invisibility, certain—wild, airy—features of resistant cultures have taken refuge and evolved, even in a world encompassed by surveillance technologies and the administration of fear. There is, therefore,

MARTA APONTE ALSINA

a certain advantage in not being fully understood. At the same time, our lives depend on seeking to understand ourselves and, also, on the attempt to understand those who are not capable of fully seeing us given all the opacities.

Today, Caribbean artists travel and intervene in remote places that perhaps their ancestors could not have imagined (or could, perhaps, only in the mists of myth). Interestingly, the routes of the "discovery" of America by European agents did not lead either to their imagined destinies. The "discovery" of the West Indies was inadvertent. "Las Indias" (India and China) are not in the Caribbean. In the late eighteenth century, the Caribbean archipelago still remained imponderable.

In 1797, two years after the Treaty of Basel was signed by representatives of revolutionary France and imperial Spain, while an invasion of English troops was being defeated in Haiti, and another contingent of English armed forces besieged the capital of Puerto Rico, an expedition of French scientific collectors was diverted from its original route. The English military government, which then occupied Trinidad and Tobago, refused to allow them to disembark there. So, shortly after the English invaders' defeat in San Juan, the French naturalists changed course and made their way to the Virgin Islands and Puerto Rico. The ship's captain, Nicolas Baudin, did not want to return empty-handed to his sponsors, the members of the Paris Directory. The account of the voyage, written by André Pierre Ledrú—which still stands as one of the first modern chronicles of Puerto Rico—came to be, if not by accident, then not exactly as planned. For that French delegation, Puerto Rico was not just unplanned; it was out of the way.

Being and living out-of-the-way entails certain obligations. According to Barbadian author Karen Lord, "[u]nmitigated dystopia in fiction may be enjoyed by those who live securely, but this region suffers under crises of economy and climate and a history shadowed by genocide. I am wary and weary of literature that depicts the utter extinction, physical or cultural, of people who still fight to survive."[4] In other words, Caribbean artists aiming to confront the "oceanic sadness of history" and claiming a right to survive must conjure new narratives in their quest for self-definition. But how do they go about that?

In 2019, Trinidadian poet Roger Robinson won Great Britain's T.S. Eliot Prize for his collection entitled *A Portable Paradise*. In one of the poems, Robinson evokes the image of his grandmother and the strong presence of an object she gave him when he was a boy. Though the object is never named, we learn that it has magical properties: It imparts inspiration and support to anyone who carries it in his or her pocket— even in the most hostile places, such as countries where capitalism feeds on human tragedies and stirs up a hatred of migrants. Portable collections could be made up of such objects. Portable museums of such objects already exist.

More than two centuries after the signing of the Treaty of Basel, it is magical to see the roles of definers and defined begin to flip. Through the communal confluence of world artists and spectators, this exhibition enables the spectators to feel exotic and disoriented in the presence of an art that explores connecting histories and opacities. It not only questions colonial logic, but also challenges the impassable opposition between an inside, where meaning is created, and an outside, where meaning dissolves. In any case, there is no inside more radical than the act of bringing forth the powerful magic of what's hidden in the pocket of the migrant.

1 Sebald, W.G. *The Rings of Saturn.* New York: New Directions, 1998. Print.

2 Mohabir, Nalini, and Ronald Cummings. "'An Archive of Loose Leaves': An Interview with Frank Birbal-singh." *Small Axe, a Caribbean Journal of Criticism* 60 (November 2019): 104–118. Print.

3 Mbom, Clement. "Édouard Glissant, de l'opacité à la relation." *Poétiques d'Édouard Glissant*. Ed. Jean Chouvrier. Paris: Presses Universitaires de Paris-Sorbonne, 1999. 248 and 249. Print. Paragraph translated by Marta Aponte Alsina.

4 Lord, Karen. *Preface, New Worlds, Old Ways: Speculative Tales from the Caribbean*. Leeds, United Kingdom: Peekash Press, 2016.

EAU DE
COLOGNE

RITA
INDIANA

If Dominicans can agree on one thing, it is that no struggle is more dignifying and fruitful than the struggle to get papers. When I say papers, I mean permanent residency in the United States, a.k.a. a green card. And, subsequently, American citizenship. This desired end justifies all kinds of means, from the illegal—paying to marry someone who has status—to the dangerous—traveling by *yola* along the shark-infested waters of the Mona Passage, which separates the Dominican Republic and Puerto Rico.

There is a raw and disaffected realism in almost all the oral accounts by passengers making the trip to the Land of Liberty from the oldest colony in the world (Puerto Rico passed from Spanish hands to U.S. control in 1898). But there is also a hint of the supernatural. It could even be said that the *yola* is an incubator of magical realism. While cooling herself off with a dip in the sea, a woman sees her dead mother walking on water. A boy, put on a boat all alone by his desperate family, witnesses the sky turn from blue to blood red. In a drifting *yola*, a new mother saves all her fellow travelers from dehydration by breastfeeding them.

While those of us who have the privilege of a tourist visa are spared these trials, we encounter other types of hallucinations. Entering United States territory—especially via the fantastically quick flight from Santo Domingo to San Juan— holds all the promise of the American Dream. In reality, Puerto Rico turns out to be somewhat less enchanting. It is a minor offshore commercial center in an isolated island. Before the internet, this kind of isolation plagued the Caribbean with a crude ignorance about other countries in the region. Insularity is an alienating evil.

I self-published my first book in 2000. It was a short work of fiction, which I was able to print because I worked as a copier at an advertising agency and my boss "lent" me the money for it. My little novel was well received. Still, like most Dominican cultural productions, it stayed within the country. Two years later, the internet worked its magic by transmitting that little volume to Professor Juan Duchesne at the University of Puerto Rico, who soon wrote to me. He wanted to make photocopies of my book so that he could teach it. Punk and DIY culture were my guiding lights back then. So the notion that my novel would be photocopied by an academic institution gratified me immensely. Thanks to

Professor Duchesne, the novel was picked up by an independent publisher in 2003. Shortly thereafter, several universities in the United States began teaching it in their courses.

That same year, Puerto Rican hip-hop artist Tego Calderón was anointed redeemer of reggaeton. After *El Abayarde*, his first album, this genre went from underground rhythm to mass phenomenon. It was on my first trip to Puerto Rico, while walking around Old San Juan and listening to the single "Con Guasa Guasa" through my headphones on my girlfriend's obsolete Discman, that I started thinking about the first world. For a Dominican person raised in Santo Domingo, which at the time was surrounded by extreme misery, strewn with garbage, and struggling with severe daily electricity and water failures, San Juan appeared to be a bubble of stability and abundance. I became addicted to Walmart, Marshalls, and Walgreens. I was hypnotized by the neatness and reassuring uniformity of these temples to capitalism. I made friends. These were people who seemed like me in almost every way—their gestures, culture, and physiognomy—except that their mobility, guaranteed by their American passports, put them light-years ahead of me.

Puerto Rico is a strange colonial experiment. Following half a century of gringo-led colonialism (1898 to 1952), an aggressive, minority-led independence movement, the Popular Democratic Party, established what we know today as the Commonwealth. The party's leader, Luis Muñoz Marín, an outspoken journalist and well-born descendant of a Spanish army officer who had battled Napoleon's forces in the Peninsular War, became the first elected governor of the territory. The Estado Libre Asociado de Puerto Rico— or ELA, as it is popularly known—is a state of indecision. Based on the 1952 agreement with the United States, which granted the island supposed autonomy while it still remained owned by the United States, the ELA has become a colony that describes itself as independent. The same mirage torments the mainland.

In my initial trips, as a guest of the university, I gave readings, led workshops, and did performance art. It was then that Puertoricanness's most complex face was revealed to me. I saw the inherent combativeness of a culture in permanent siege. There were my new friends, mostly academics

and artists, who were always engaged in argument; there were small private and public acts of resistance; there was the language, the perspectives, the art itself.

In 2007, after several years trying to make it in New York, I moved to Puerto Rico. I didn't have papers at the time, which meant I had to return to the Dominican Republic every five months so that I could re-enter as a tourist. At night, I staffed the front desk of a small hotel in Santo Domingo and washed sheets for several other hotels. During the day, I folded thousands of those sheets at the Colonial Laundry (that truly was the name of it!), and composed my best song while watching them spin inside the industrial dryers. I fell in love with a married woman and had no money. My stupidity was such that my status as a struggling artist filled me with pride. I used to fantasize that this cleaning exercise also cleaned up the accumulated karma of other lives and that, thanks to this, my immigration situation would soon be magically solved.

Dealing with bodily fluids left by tourists on those bed linens led me to discover my place in this soul-crushing machine called the Caribbean. I began writing clearly lesbian, tropical, and gothic verses for an imaginary interlocutor. This artistic coming-out-of-the-closet was only possible in the queer capital of Las Antillas, where the local independent scene adopted me as one of its own. Comfort, as Lolita Lebrón[1] explains in a YouTube video, is an enemy of independence.

It is impossible for me to separate Puerto Rico's relative tolerance for difference from the social struggles in the United States. For years, that simplistic equation left me in a state of indecision about whether I should stay or make another attempt at life on the mainland. The Commonwealth was working, so much so that in 2017 I was able to marry another woman. That was a marriage for love. And through it, I finally got my papers. But three months after that happy conclusion, Puerto Rico was hit by Hurricane Maria. The category-five tempest brought a level of destruction the island had never seen before and, thanks to the idiocy of the government, claimed thousands of lives in the days after it hit. Like an addict going through withdrawal, Puerto Rico was completely undone by its overdependence on federal funds. In villages isolated by landslides, where whole

communities were without light, water, or food, people were forced to bury their dead in their own backyards.

My bubble was now plagued by physical deterioration, social precariousness, and the futility of a collapsed government. It was similar to what happened during La España Boba—a period of about ten years in the beginning of the nineteenth century in which the Dominican Republic and other Spanish colonies were abandoned to their fate because all of Spain's resources were being poured into the Peninsular War—when men strolled the streets wearing women's dresses because their own clothes had rotted away from overuse. There were rumors in San Juan that money from FEMA (the Federal Emergency Management Agency) was coming at any moment. But a rescue was never going to happen.

The Mona Passage continues to be full of sharks and hallucinations. Nowadays, many Puerto Ricans cross it searching for a job in Santo Domingo, where currency laundering runs rampant. I am still in Puerto Rico and will continue to stay here until I get my American passport.

1 Lolita Lebrón (1919–2010) was an outspoken
 advocate of Puerto Rican independence. In 1954,
 two years after Puerto Rico became a common-
 wealth of the United States, she led an armed
 assault—along with Rafael Cancel Miranda, Irvin
 Flores, and Andrés Figueroa—on the United States
 House of Representatives that left five congress-
 men injured. After she had served twenty-five
 years in prison, her sentence was commuted by
 President Jimmy Carter. She remained an impor-
 tant figure in Puerto Rico's fight for sovereignty
 until her death.

Elisa
Bergel Melo

Minia
Biabiany

Christopher
Cozier

Tony
Cruz Pabón

Sharelly
Emanuelson

Nelson
Fory Ferreira

Madeline
Jiménez Santil

Tessa Mars

Ramón
Miranda Beltrán

José Morbán

Guy Régis Jr.

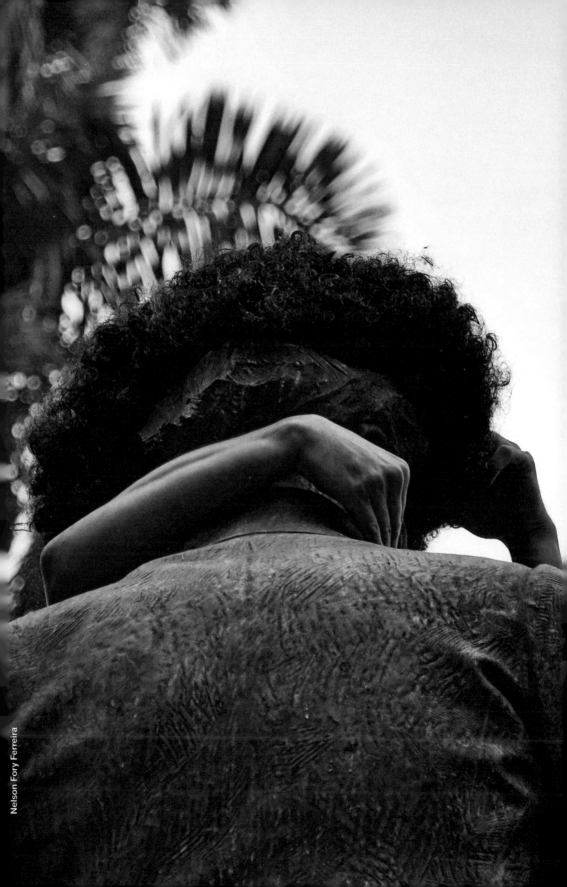

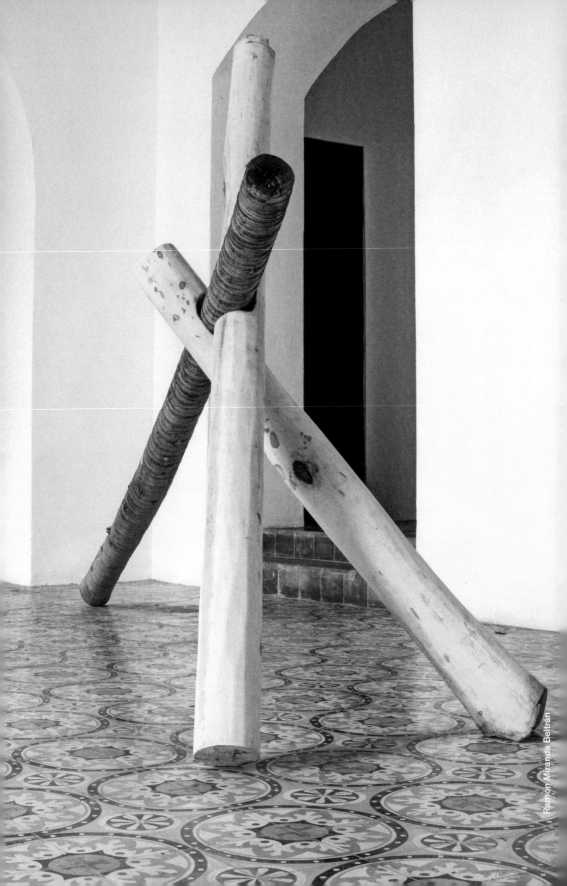

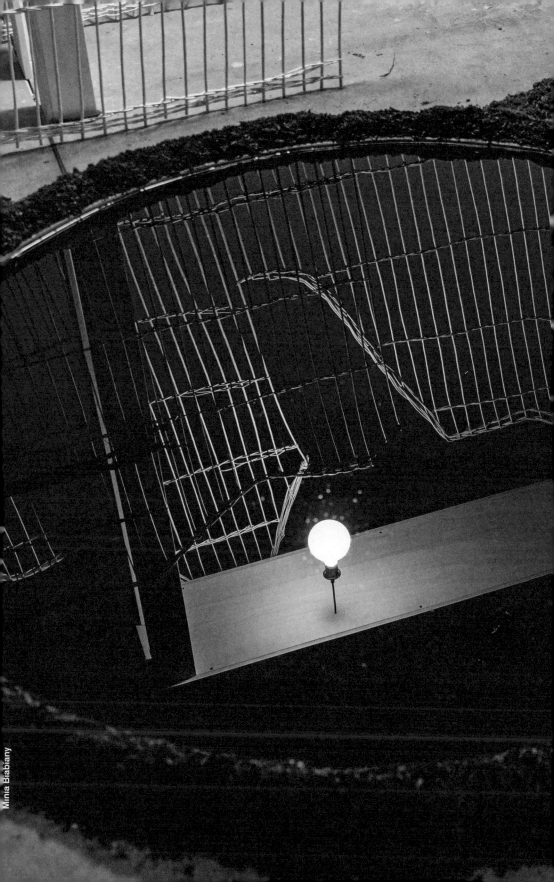

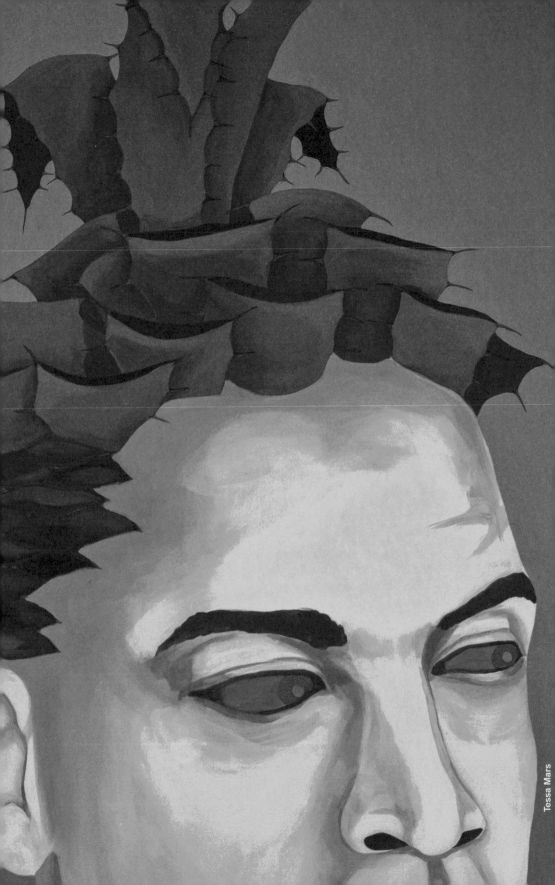

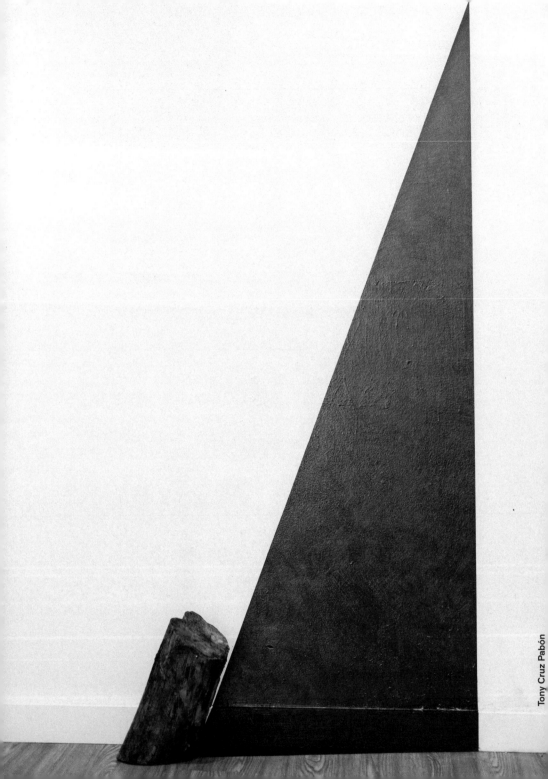

Tony Cruz Pabón

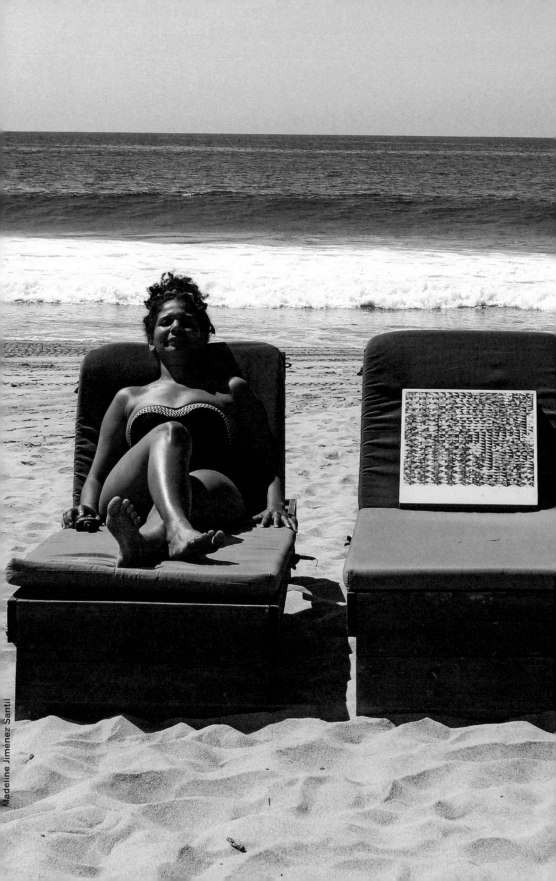

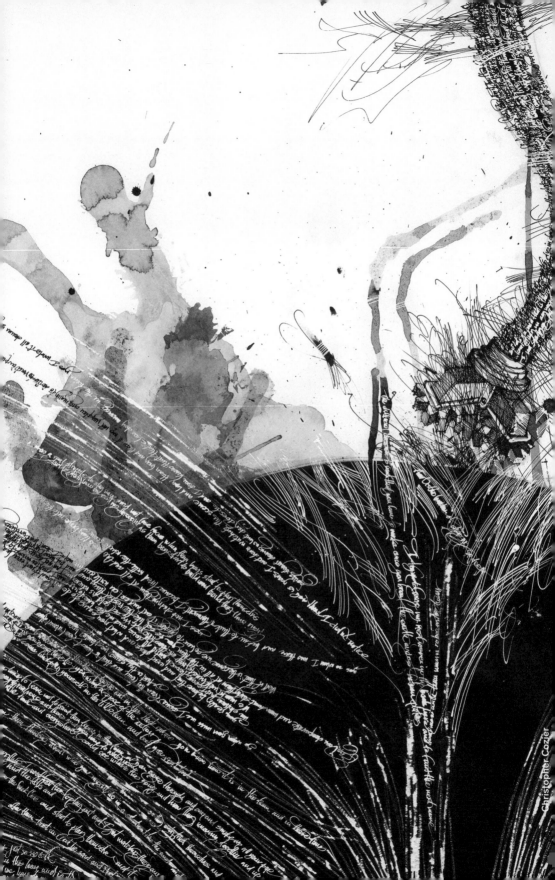

Christopher Cozier

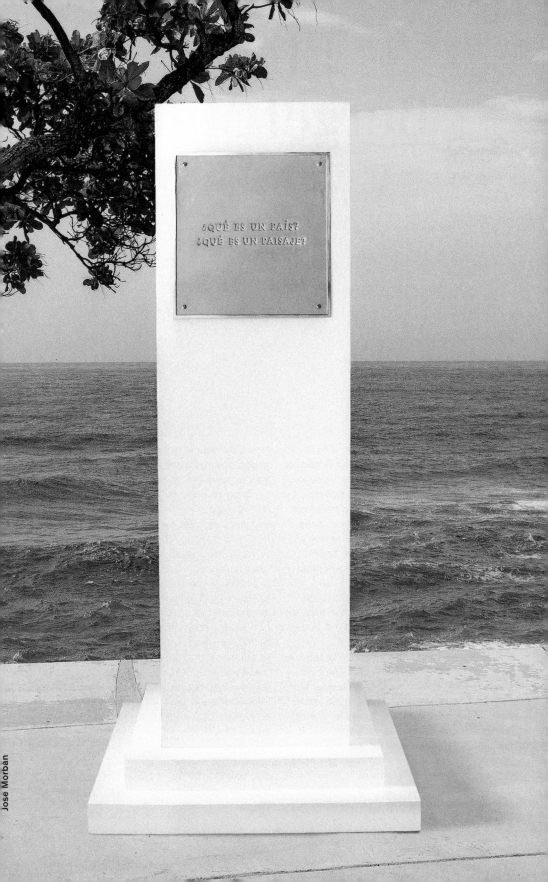

Elisa Bergel Melo

You have lived and worked in several countries. Your recent solo show in Santo Domingo, which was titled *Location, Location, Location*, deals with how values—for both property and for art—are determined in the periphery. Given those points of reference, what does *homeland* mean to you? Is "home" where you are presently? Is it where you were born? Is it something you take with you wherever you go?

Homeland for me is a very phantasmal concept. As a survival skill, I detached from the idea of returning to a place I could call home. This detachment gave me the opportunity to look forward and not romanticize Venezuela, where I was born. That does not mean I'm immune to a certain undefined sadness that sometimes catches up with me. At the same time, it has been a privilege to live in so many places. This way of life has cultivated me. I would not call the Dominican Republic—where I live presently—my home, although some of my family members live here. You could say home, for me, is where my family is, and they live all over the world.

How does your very particular sense of geography and place shape your practice and your concerns as an artist?

In my practice, I try to find patterns in how my behavior relates to the bigger scheme of things, for example my interaction with mobility, the internet, or my family archives. My interest in such behaviors comes from being an emigrant, a condition that grants me the privilege of constantly experiencing newness. I observe things in my daily life that the people around me are used to seeing. Being unhabituated, I am more apt to notice them. This includes both deep-rooted traditions and ordinary living solutions people create. I frequently contrast these unfamiliar practices with my way of thinking and appreciating. My artwork is an attempt to make sense of what it means to be a citizen of the world. Geography, people, and habitual activities are probably my biggest influences.

One month after being known in that island features artists from all over the Caribbean. Do you think such a confluence will resonate

in Basel? What do you hope the exhibition will achieve?

Given that I am the only artist in the exhibition born in Caracas, my goal is for my contribution to be as thought-provoking as possible. I know very little about the art scene in Basel, so it will be interesting to see what impact the exhibition has there. Whenever I take part in a cross-cultural effort between Europe and Latin America, my wish is for the discussion about our shared history to intensify. I think the subject matter of this exhibition serves that purpose perfectly.

How do you describe your work for this exhibition? What was your process and motivation?

I began developing my project for this show in 2019. It grew out of a conversation I had with my boyfriend, also an artist, about the difference between people from the sea and people from the mountains. He casually mentioned he was born on an island—he is from the Dominican Republic—and I had kind of a "come to Jesus" moment. I realized that not everything is continental land, and that I, too, was in fact living on an island. Sounds silly, but this unleashed many reflections about islands and how vulnerable they are.

For the exhibition, I developed eighty-five imaginary shapes by mixing all of the Caribbean island nations and mimicking the geographical circumstances of Hispaniola. These faux maps have been made into small wooden pieces, which I used to block the light in a limited series of cyanotype prints. The finished work includes the prints, as a metaphor for a new Caribbean Sea, and the wooden pieces as a floor sculpture.

What artists—living or dead—have been most influential on your practice?

That is a difficult question to answer! I have to start with Carla Herrera-Prats, the Mexican conceptual artist, who died in 2019. I had the pleasure of studying under her direction during SOMA Summer 2016. She taught me a new way to conceptualize my work. She was challenging and endearing at the same time. Her practice was deep, playful, insightful, and always current. She came from a photographic background, but utilized research in her individual and collective work in a way that struck

me as being particularly relevant to our times. My other big influencer is Charlie Quezada, an emerging Dominican painter. He and I have shared a studio for the past four years. He has changed my way of thinking about painting and the rhythms of art making, helping me find the right balance between the digital and the handcrafted elements in my work. Initially, we took the space together for economic reasons. Eventually, it became a necessity in terms of problem-solving and debate about art itself.

Elisa Bergel Melo (b. 1989) is a Venezuelan artist, originally from Caracas, who has lived in Boston, Barcelona, and Costa Rica, and now resides in Santo Domingo, Dominican Republic. She studied photography at Roberto Mata Taller de Fotografía, in Caracas; at the New England School of Photography (NESoP); and then in Costa Rica at Veritas University, where she earned her BA in photography. Her work has been shown in the Wrong Biennale *Isn't the World Just a Big Pyramid Scheme*; at Casa Quien, in Santo Domingo; and at the Beatríz Gil Gallery, in Caracas.

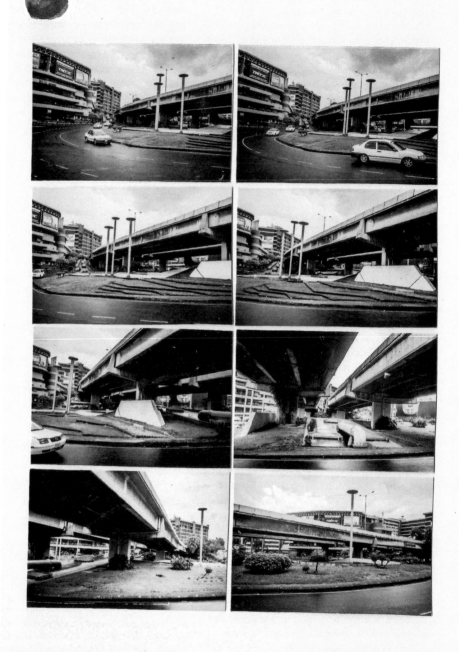

RUTA 51-55

MIÉRCOLES 10:34 am

Previous pages: *Bitácora (Navigation)*, 2015,
mixed media
Left: *Por Arriba y Por Abajo (Above and Below)*, 2020,
digital photographs
This page: *All Museum Goers Look the Same* (detail),
2019, digital photographs

Minia Biabiany

Your piece for *One month after being known in that island*, titled *Toli Toli*, was developed for the 2018 Berlin Biennale. Can you describe this work and your motivations behind it?

Toli Toli is a video installation comprising a ten-minute projection and freestanding bamboo weavings that organize the viewers' movements while projecting shadows onto their bodies. It was produced for *We Don't Need Another Hero*, the 10th Berlin Biennale, and is part of a series of video installations that involve storytelling based on the territory of Guadeloupe. I was born and grew up in the Lesser Antilles in Guadeloupe. As a French territory, it has a strong identification with French assimilation policies. But it also has a singular culture fed by conscious and unconscious resistance strategies challenging this French control.

What does *Toli Toli* mean?

"Toli toli" is the Creole name for the chrysalis of a butterfly that moves its tail when taken from the soil. Kids in rural areas in the 1950s and '60s would sing a song to it: "*Toli toli montré mwen chimen a…*," meaning "Toli toli show me the way to…" and then the kid would say the name of a town or a country she or he knew or imagined.

The demand that the toli toli show the way to somewhere elsewhere was my starting point to talk about how we relate to the land, about the disconnection we have with where we live, about the disconnected knowledge, magic, and force of that place. The global decolonialization moment we are observing and taking part in today is undoubtedly deeply needed. But now that our voices are slowly being recognized and legitimated, my question is how do I transform my reality, my relation to the world, my relationship with myself? In *Toli Toli*, the traditional kids' song is altered with a new demand to look at where we actually are, to be shown the path to the sea and to home. I built that video while being back in Guadeloupe after many years abroad.

At that time, I was realizing how little is said about the political situation of Guadeloupe and its historical fights against assimilation.

You have called this work "an aperture—a possibility for an intimate gaze." This formulation suggests a remove, like looking through a camera lens, that is not about having a shared experience with other viewers yet still allows for empathy, intimacy, vulnerability. Is that your hope for visitor interaction with, and reception of, your work in Basel?

Yes, each context conditions a certain type of gaze, a mode of observation, a capacity of reception. The work should play with those by provoking its own rhythm, its own pace.

You divide up your practice into several portfolios on your website, including photography, installation, video, sculpture, and drawing. One category, "immanence," stands out from the rest. How would you describe your immanence work?

My immanence pieces are directly related to the spaces where they were made. Where they are made informs what they are. They all begin from the question: *What constitutes a particular space as a place?* The difference between a place and a space has to do with experience as well with time. When a body relates to a space's specificity, to the physical/material/historical/spiritual surroundings, by breathing/looking/circulating/inhabiting, then that space becomes a place. The attention of the spectator is the first criterion for the poetics of a place to emerge.

And how does the immanence work relate to your overall practice?

In all of my work, the disposition of elements in a space comes from an understanding that the relationship between the objects is more important than the objects themselves. I am talking about the basic cerebral capacity of connecting what we see to how we view ourselves and our pasts. I like to work with that intuitive, sensitive level of understanding to suggest a hidden guidance to the gaze.

You have described your ongoing project *Doukou* as a way of "exploring the act of learning by using body perceptions to approach concepts of Caribbean authors."

How have *Doukou*—and, more broadly, literature—informed your artistic practice?

Doukou is my pedagogical project. It grew out of the pedagogical collective Semillero Caribe, which I launched in 2016 in Mexico City with Madeline Jiménez and Ulrik López. The question "What is a learning process?" fascinates me. We can learn intuitively or via readings and teachings. Yet what is needed to actually learn something? The body! The body—especially the walking gaze of the spectator—is what I think about when I organize the elements of an installation. The body and the emotions are the keys to any learning process. In French, "learning" is *apprendre*. I like to think it can also be understood as *à prendre*, which means something to take when you are ready to receive it. Learning is a changing level of understanding, unconscious or conscious, that can take place anywhere. Learning is a power in which we must regain confidence and autonomy.

Minia Biabiany (b.1988) is a Guadeloupean multimedia artist from Basse-Terre who lives and works in both Mexico City and Saint-Claude, Guadeloupe. She studied at the École Nationale Supérieure des Beaux-Arts in Lyon, France, and is the recipient of the 2018 Horizn Award, the 2019 Prix Sciences Po Paris Award, and the 2019 Tout-Monde festival award for visual arts in Miami. Her work has been shown in the 10th Biennale of Berlin, at TEOR/éTica in Costa Rica, Witte de Wite in Rotterdam, and Cráter Invertido and Bikini Wax in Mexico City.

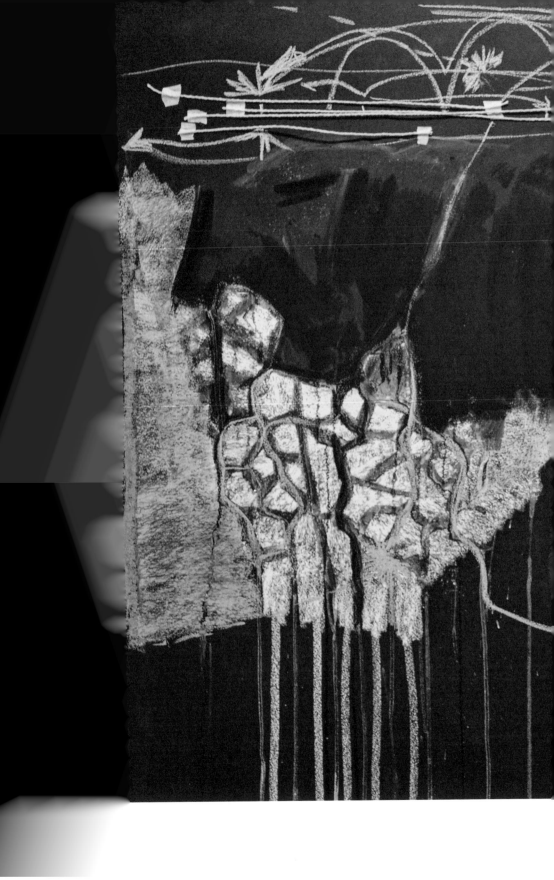

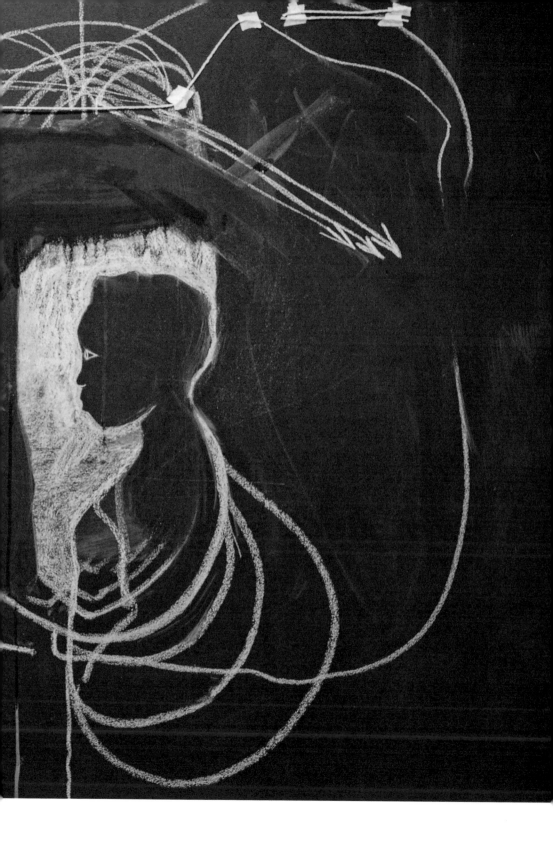

63

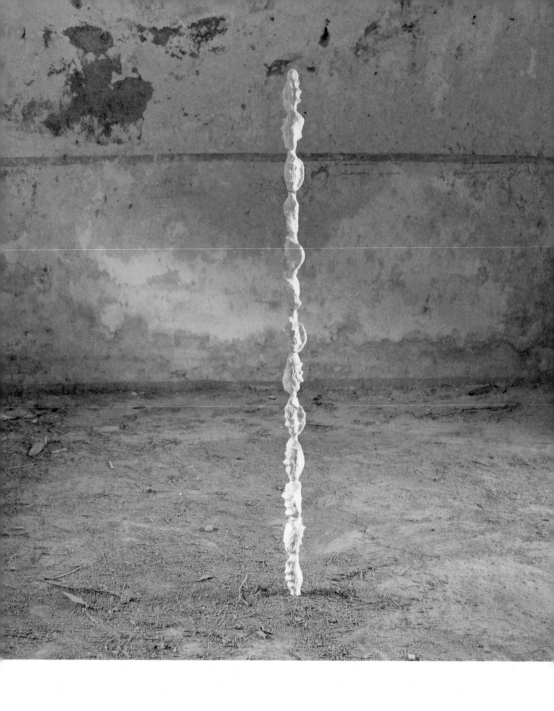

Previous pages: *Blue Spelling: A Change of Perspective Is a Change of Temporality,* 2016, video still
Above: *Doubout' (Doubt),* 2009–2017, cotton
Opposite, top: *Toli Toli,* 2018, video still
Opposite, bottom: *J'ai Tué Le Papillon Dans Mon Oreille (I Killed the Butterfly in My Ear),* 2020, mixed-media installation; © Camille Olivieri

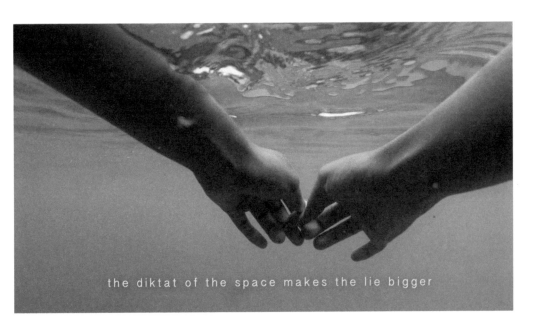

the diktat of the space makes the lie bigger

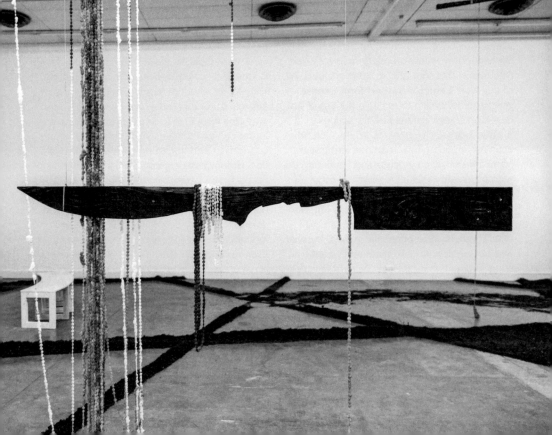

Christopher Cozier

How would you describe the work you are presenting in *One month after being known in that island*?

The pieces are drawings from my *dig & fly* series, which was shown at the 2019 Sharjah Biennial. They follow on my *Entanglements* (2015) and *Gas Men* (2014) video projects. All of this work began, in various forms, some years ago as I began to evaluate the use of academic and empirical research practices in my own work and in general. While such practices may open up new readings and underscore a historical connection and continuity, the rearrangement of visual research vocabularies could also perpetuate a denial or deferral of the visual present and future at this juncture of readability and exchange. For example: What shaped contemporary life in the Caribbean was not eighteenth- and nineteenth-century sugar production exclusively. Nor was it solely industrial tourism. Oil, gas, and bauxite extraction played a role. Think of OPEC, the Cold War, and Bandung, or the Caribbean's brief moment of federal government in the late 1950s, long before Europe's Union, which is now in collapse.

Since 2006 you have been the director of Alice Yard, an artist residency and exhibition space you cofounded in Port of Spain, Trinidad, where you live and work. Given that project, what does community mean to you?

I never thought about it so directly. My work is inherently collaborative and conversational. Visually, it's about producing an experience, an awareness. Communities are formed through empathy and shared vocabularies. They are about context-building. Alice Yard is about supporting and engaging creative investigation. Nothing was expected of us in places like Port of Spain, where we were initially brought as property to work in external labor camps of European powers posing as nation-states with colorful flags and promises. Imagine trying to build civil societies with such a foundation? Even now, we still struggle self-destructively by constructing compliant opportunistic alliances to attract international art funding or to become visible. We are not "developing" societies. We are "recovering" sites in the process of becoming societies. To build anything, to imagine, or to dream, is an act of defiance—not in a performative way as entertainment, but as a way to

stay sane. Look at how violent these alleged "paradises" are. Some of the smallest islands and populations in the region have the highest murder rates on the planet. We know how we are called upon and funded to entertain. My concern is what we mean to ourselves and to each other. How we value each other remains a question.

Given your commitment to community-building in your hometown, how have your experiences living and working abroad affected or informed your practice as an artist, as a citizen?

I am not sure where or what "home" is anymore. Why is there so much invested in keeping me in one place or in one conversation? I have become very interested in itinerancy, in the way we have navigated social spaces across time and geography—as property, as subjects of various crowns, as citizens of possible republics, and now also as borderless communities and networks. If you look at the great thinkers from past generations, like James or Naipaul or Wynter,[1] they were on the move, searching and breaching territories both physically and mentally. However, after saying all this, news of the pandemic revealed that "home" is where I was trying to get to before the borders closed. My family, my studio, my desk is here.

What impact do you foresee this group exhibition having in Basel?

I hope it will further expand and diversify understandings of the region at home and abroad. I think the Caribbean is always shifting and expanding as an ongoing sequence of ideas. I am always excited when curators from our space and experience get into the game, not just to generate cultural display in the usual places, but when we ourselves can become agentive in producing critical awareness about what we are really doing along the way. The tendency to oversimplify or create territories is not new. It is a part of the Caribbean story and must be seen for what it is. We must keep responding inventively.

What artists have been most influential on your practice?

What—and who—influences me changes all the time. I listen to lot of music: Fela Kuti,

James Brown, Bob Marley, and early calypso from the classic period. For a while, I was playing a Fania All-Stars collection in my car to the point that my kids became traumatized. Lately, I listen to Afrobeat in the studio while working. In terms of what artists, it's eclectic. But I see a thread: In my developing years, it was people like David Hammons, Joseph Beuys, and Hélio Oiticica. Right now, all my peers in the region and the diaspora excite and inspire me. Every time I open Instagram somebody somewhere is up to something cool—instigating an idea or producing an awareness. I wish I had the resources to move around and see and experience it all directly, or to bring the work back into the region. Though this might bring up an old and ongoing question about the visa in your passport or wallet.

1 C. L. R. James and V. S. Naipaul were prominent Trinidadian historians and writers—Naipaul won the Nobel Prize in Literature in 2001—and Sylvia Wynter is a renowned Jamaican novelist and scholar.

Christopher Cozier (b. 1959) lives and works in his native Trinidad. He earned a BFA at the Maryland Institute College of Art, in Baltimore, and an MFA from Rutgers University, in New Brunswick, New Jersey. A 2013 Prince Claus Award laureate and a codirector of the contemporary art space Alice Yard, which was founded in 2006, Cozier investigates how Caribbean historical and current experiences inform our understanding of the wider contemporary world through his notebook drawings and video installations. Cozier's work has been shown widely, including in numerous biennials, including in *Infinite Island* at the Brooklyn Museum (2007), *Afro Modern: Journeys through the Black Atlantic* at the Tate Liverpool (2010), *Entanglements* at the MSU Broad, East Lansing, Michigan (2015), *Relational Undercurrents* at Museum of Latin American Art, Los Angeles (2017), and *The Sea Is History* at the Historiskmuseum, Oslo (2019).

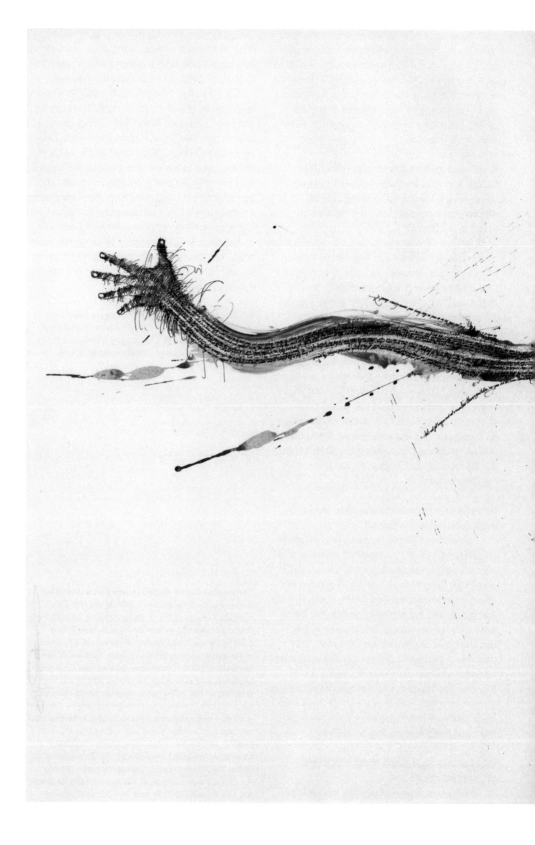

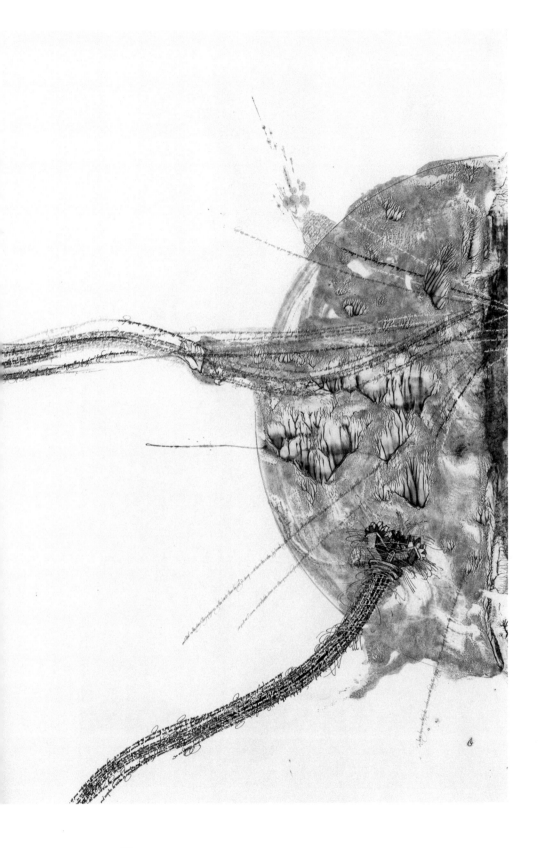

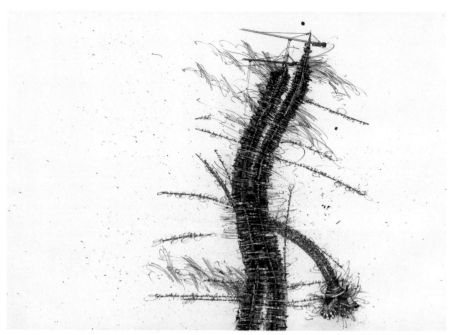

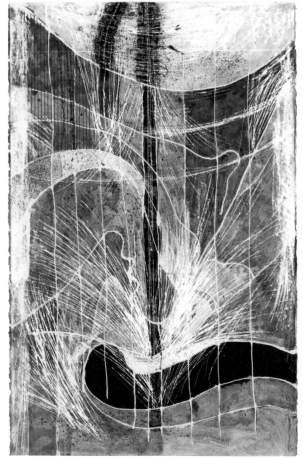

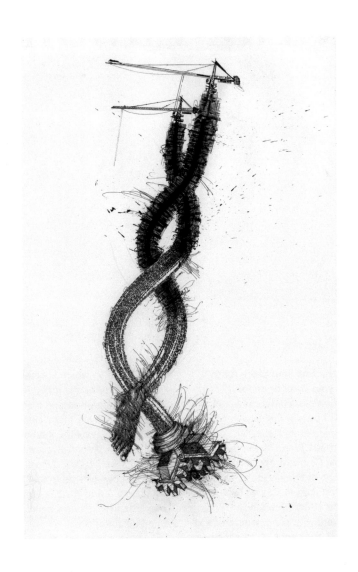

Tony
Cruz Pabón

How would you describe your piece for this show? What was your inspiration for it?

La Clave/La Llave is a video installation piece. It was first shown at Fotonoviembre, at the Museo Municipal de Bellas Artes in Tenerife, Spain, in 2017, and it was restaged for the 2018 Berlin Biennale. My starting point was an investigation of tropical music album-cover artwork produced in Puerto Rico and New York from the 1960s through the '80s. I mixed these covers with song lyrics and text quotations, as well as images of art, cinema, advertising, and historical events. I have presented this investigation as an installation and a talk. For One month after being known in that island, I added a video component.

Your previous bodies of work seem less occupied with popular culture. Do you see this one as a departure?

More than a deviation, I see this piece as a parallel investigation that occasionally connects with my other works through music. The clearest example is my 2013–14 project

Nube (Cloud), in which I presented a series of drawings and objects that referenced both the climate and the landscape of Puerto Rico. Some of the drawings are literally song titles that somehow touch on the theme of the weather. Another work that involves music directly is my 2012 Five albums—LP—by Ismael Rivera (Cinco discos—LP—de Ismael Rivera), in which I used both A and B sides of five of the late salsa legend's LPs as a matrix to print them in ten intaglio works.

Is this piece more about new kinds of cultural traditions, then?

For La Clave/La Llave, I focused on the strategies graphic designers used to create album-cover art. I'm not coming at this from the point of view of tradition, necessarily. But I am interested in looking at how these strategies are still present—and meaningful—in our culture. It's like the syncretism that took place between the Catholic and Yoruba religions during the Caribbean colonization, in which the Catholic idols became the containers of

the Yoruba deities. The Catholic images took on a new meaning but did not change their aspects. In today's art world this might be seen as cultural appropriation. I propose that it is a strategy: creating images and content that are rooted in tradition while still being useful today.

In your *Distance Drawings*, your homeland acts as a "base" from which you calculate certain measurements. How does where you live come to life in your work?

My work definitely responds to where I live. The drawings of distance suggest the territorial limit of the island. But they are not purely about measurement. I also try to shape the experience—which always results in failure, because it is impossible to render the time involved or to accurately translate the travel experience. The horizon is a very important metaphor in my work; it places us in time and space. Currently, I want my work to respond to the island's tropical climate—to the rain, saltpeter, and erosion—so that I can show the landscape from this point of view. Here, nature is exuberant. And it is difficult not to take it into account. *Nube (Cloud)*, the piece I mentioned earlier, best illustrates these ideas, since I work directly with them in the final composition.

What are some of your earliest memories of art and visual culture?

I think my introduction to visual culture was television. Early on, I started drawing cartoons. When I saw that I could draw a reasonable likeness of Bugs Bunny, I began to sketch all the characters I watched on TV. In my second year of high school, I asked my parents if I could change schools, because mine had no art classes. They agreed, and, at some point, the art teacher at my new school lent me an art-history book with images that really impressed me. I remember seeing El Greco's paintings and making the decision to study art. But I didn't have access to museums, galleries, or art spaces until I arrived at university.

What artists have been most influential to your practice or to you personally?

There are many. But if I had to choose one, it would be Oscar Muñoz. When I got to know his work, it blew my mind because of the way it stretched the meaning of drawing and photography. Thanks to him, I now think of drawing as an ephemeral medium, since most of the drawings that are made disappear. Oscar plays with this characteristic of the medium, making it both the essence and the idea of the work. He does the same with certain photography techniques, giving life to the image with light. In his work *Aliento (Breath),* for example, he replaces light with breath. It truly inspires me.

Tony Cruz Pabón (b. 1977) is a Puerto Rican multimedia artist who lives and works in San Juan. He earned his BA at the Escuela de Artes Plásticas de Puerto Rico in 2000, and then received a PhD in research and artistic practices from the Universidad de Castilla-La Mancha in Spain. In 2009, he helped create Beta-Local, an organization dedicated to promoting arts and critical discourse on the island of Puerto Rico. His works have been shown internationally, including in Berlin, São Paulo, Bogotá, Los Angeles, and Glasgow. He is the recipient of a 2018 Joan Mitchell Foundation Award and a 2019 Robert Rauschenberg Foundation residency.

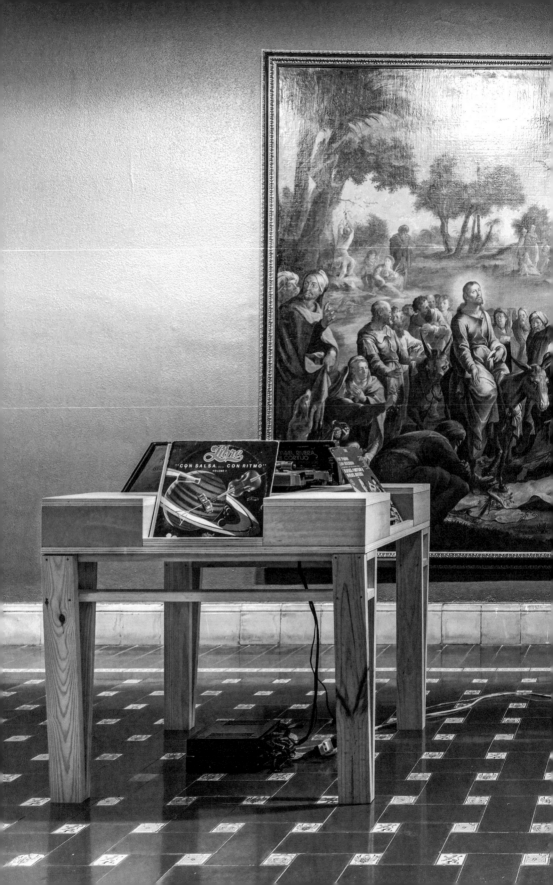

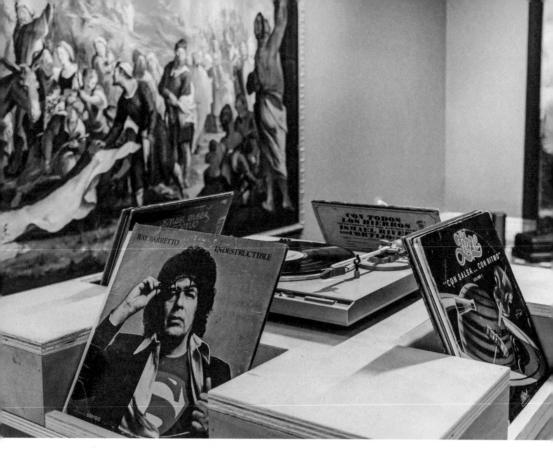

Previous pages and above: *La Clave/La Llave (The Key/The Passcode),* 2018, mixed-media installation with wood, LP discs, turntable, and C prints; Photograph by María Laura Benavente
Opposite: *Nube (Cloud),* 2013–2014, mixed-media installation with graphite, paper, cardboard, wood, water, rust, fire, and video; Photograph by Alan Dimmicke

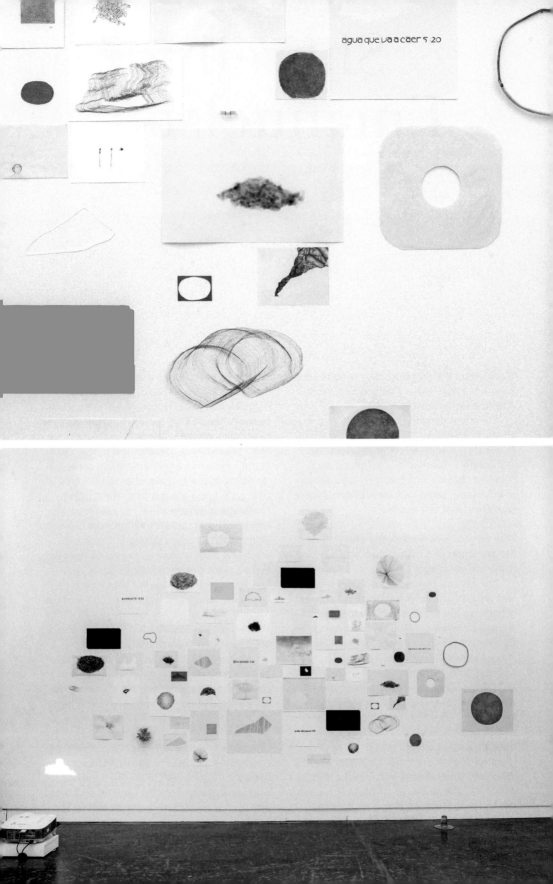

Sharelly Emanuelson

Questioning the meaning of community has been a through line in your practice. What does the term mean to you?

For me, *community* is about difference—it's a coming-together of different people who, in one way or another, converse, complement, and connect. *Community* connotes a particular relationship, one that involves a sense of belonging, being validated. Community is something that you can feel.

How do you trace community with Uniarte, the art center and cultural hub you founded some ten years ago?

The idea for Uniarte came to me when I was studying in the Netherlands. Art was not something you went abroad to study professionally. I was one of the very few from the Caribbean who deliberately choose to do so. When I arrived, I saw there were platforms that represented artists from Europe or even Africa. But I sensed there was a difference and felt that I didn't fit into the existing platforms. I wanted to meet others from the region and initiate conversations and dialogues, in the hope that we would perhaps produce projects together. That desire is what inspired Uniarte. When you study abroad, you face the danger of altering your aesthetic or character. Getting this group together—building workshops,

organizing events—was a way to protect myself from this danger. In 2016, after ten years in the Netherlands, I moved back to the Caribbean and made it my mission to create a space here based on the knowledge and experience I had gained there. Uniarte now has a space in the city center where artists can come for research, and where we offer residencies to both local and visiting artists. The biggest challenge is to remember—as I was recently reminded—that there are differences between an artist who studies abroad in Europe, an artist who stays abroad and never comes back, and an artist who never leaves the island. The key for me is to see the importance of each artist and his or her production process.

How would you describe the work that you are showing in this exhibition?

Moments (2013) is a single-screen video piece. It was the first film I made outside of my conventional documentary work. The material comes largely from my personal archive, including footage from movies my mother made of me and my little brother growing up and film I shot as a teenager with my Hi8 camera, when I recorded everything I could see. *Moments* tells the story of being part of the [Netherlands'] kingdom but also from the Caribbean. It is my way of showing why an accurate awareness of

one's own representation is so important. Back in the day, when I saw news about my island or about the Caribbean generally, I always found it negative. I had the same experience when I looked at archival footage of the island from the 1900s and journal entries from visiting soldiers. When people come to Curaçao to research the Netherlands, as with any other European country, there is a vast history to study. In Curaçao's case, just about everything was documented by outsiders. Because whoever had the power to write was who determined how things got written down. So one particular view or perspective is repeatedly presented. I wanted to challenge that perspective.

So a big part of your message is that who is telling the story, and how they are telling it, are as important as the story itself?

Definitely! There is this whole notion that "there was nothing" in the Caribbean. My question is, *Nothing according to whom?* When you really look at the Caribbean, there is never just one narrative. Perhaps larger nations are dealing with this now, but in the Caribbean cultures have been coming together for generations. The Caribbean has long allowed for cacophony. Sitting side by side with different geopolitical stress factors and realities has meant that many perspectives were forced to coexist. How do you recast a particular narrative that has been dominated by an unrepresentative past? *Moments* was an attempt to recast my personal narrative.

Your recent work, such as *En Mi Pais* (2018), seems to be less personal and more about multiple voices and other perspectives.

True. In that installation, there are seven "tour guides." Each leads a different tour of Aruba. Some speak Papiamento, others speak Dutch. They discuss locations around the island. Some of their information can be proven to be correct, or historically factual. Other bits are made up, based on what those characters have heard or what others have told them. There is a lot we don't know about ourselves, right?

Do you have any specific goals for this group show in Switzerland?
I'm hoping for curiosity on the part of the audience. I'm hoping this show will raise

questions, because dialogue comes from asking questions.

What artists or other creative people have most influenced you, or left the biggest impression on you?

For sure it would be the Dutch-Peruvian director Heddy Honigman, because of *Metaal en Melancholie* (*Metal and Melancholy*), her 1993 documentary. As a child, I was only seeing Hollywood blockbusters and soaps. That's all I could get in the cinema and on television. Then I saw this documentary about taxi drivers in Lima, Peru, in the 1990s. Watching it was an "Oh, wow, this is gorgeous! This is a real-life story on film!" moment for me. From then on, I was in love with the documentary genre. Another big influence was Frantz Fanon. I was twenty-six when I read *Black Skin, White Masks*. The fact that I had never heard about him before said so much about the education we get in the Dutch Caribbean islands. It made me so angry and brought up so many emotions, because I was twenty-six when I read it, and Fanon was twenty-six when he wrote it. It showed me a lot about what we are seeing or not seeing about ourselves. It led me to Glissant and other Caribbean minds, and still inspires me to make the work I need to see.

Sharelly Emanuelson (b. 1986) is a filmmaker and visual artist whose work has been recognized with numerous honors, including most recently the 2020 Volkskrant Visual Art Prize, which is given to Dutch artists under thirty-six. After receiving her BA in audiovisual media from the School of the Arts, Utrecht, she earned her MA in artistic research from the Royal Art Academy, The Hague. In addition to her art practice, Emanuelson is a guest lecturer at the University of Curaçao and the founder of Uniarte, an artist-run foundation that enhances the visibility and development of emerging artists in the Caribbean. Raised in both Aruba and Curaçao, Emanuelson lives and works in Curaçao.

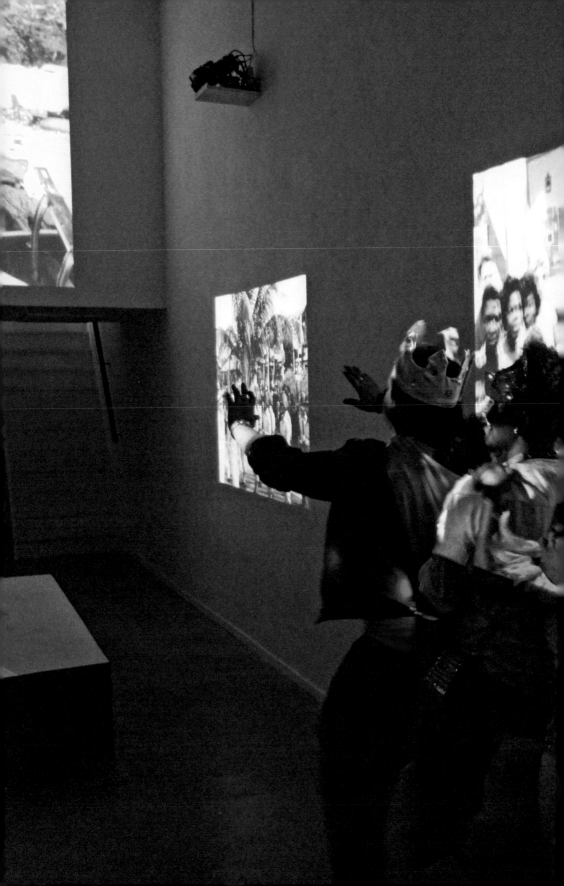

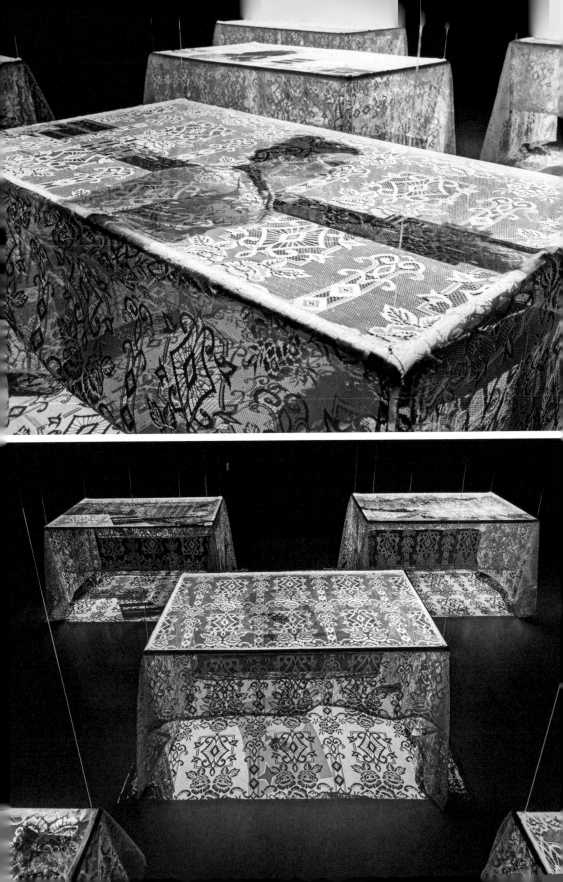

Previous page: *Hidden Transcript*, 2014,
performative event
Opposite: *En Mi Pais (In My Country)*, 2020,
audiovisual installation
Above: *Moments*, 2013, video still

Nelson Fory Ferreira

How would you describe the work you are showing in this exhibition?

The piece is a series of photographs of art interventions I've performed at public monuments that represent Spanish heritage in Colombia. Since 2008, I have been adorning these monuments with Afro wigs to represent the black element in my country's racial mix. In a way, blacks were the ones who fought for the liberation of slaves and for the end of slavery. It is remarkable how the country's dominant white elite has managed for so long to conceal or stigmatize black participation in our political history while promoting the idealization of non-black heroes. By bewigging these monuments, I create social awareness of Cartagena's true history and make public a past that has been kept in the dark not only for most Colombians, but for the world at large. As temporary features, the wigs disrupt the experience of people visiting the intervention sites. They force onlookers to notice black elements in our culture and to see a contrast to the shallow and lifeless statues erected to highlight the white elements of our history.

Why did you choose this particular project for this exhibition?

The title of the piece, ¡La Historia Nuestra, Caballero! (in English, "Our History, Sir!") comes from a small poetic fragment in a song titled "Rebelión," by Cartagenan musician Joe Arroyo. Both the song and my piece are about the desire to express the true history of the black people during slavery. Undoubtedly, ¡La Historia Nuestra, Caballero! is not a formal protest. Rather, it is an appreciation, from an artistically plastic perspective, of how black elements could be conjugated in urban visual dynamics. Its purpose is to become a benchmark for citizens to reflect on the appropriation of a history as a way of resisting that past and questioning how it reveals our identity in our collective imagery. That purpose seems very aligned with the curators' goals for this exhibition.

Public interventions and protests are a big part of your practice. How does this piece reflect your larger practice?

My practice is about uncovering both the visibility and invisibility of how we, as a culture, relate to history, to black memory, and to the current way in which we are being recolonized by foreign companies. For this reason, I consider it appropriate that my contribution be linked to that of those demanding history be told as it truly happened or is happening, in order to achieve real historical recognition. I want that recognition to be not just in written text. I want it to become an integral part of a new society that is gradually succeeding at overcoming discrimination and integrating individuals into dynamics of dialogue and coexistence. Last year, for example, as a member of RoZtro Art Collective, I participated an exhi-

bition entitled ¿*Suficientemente Negro?*, which was about highlighting the life and work of the first and only black Colombian president, Juan José Nieto Gil, who held that position for just six months in 1861 and has largely been whitewashed out of history, and whose only known portrait has been kept hidden in the basement of Cartagena's historical archive. My project for that show, *A Cruel Touch*, is a video work based on that hidden portrait, but focusing on an image of Melchor Pérez, a *champeta* singer, whose songs are about black history in Latin America. In the video, Melchor's physical appearance is digitally painted, but slowly his natural ethnicity is transformed into a Caucasian one.

How does your life in Cartagena inform your artistic practice?

Cartagena de Indias, my hometown, is undoubtedly my main source of inspiration. The totality of its cultural and gastronomic richness embodies an impressive magic, which is somehow reflected in my personality. I was born and raised in one of the city's poorest areas. My old neighborhood is essentially a favela. It is a place where subhuman living conditions, drug addiction, abuse, indifference, and despair prevail. Not many survive such a bleak scenario. But for those that do, the daily desolation can motivate you to get ahead in life, to show your parents that all their effort and dedication to your development were not in vain. I think a big part of what drives me is my past in this city. Another big part is my present here. Artistic achievement in this city is anything but easy. And work that involves strong anti-racism content is especially difficult to show here. Perhaps it is because I have already overcome so much that I don't focus on the barriers, but continue to create and develop my artistic projects that are fueled by the very specific history of this place.

Who has most influenced your practice?

Several of my professors are among the people who have shaped me and my practice. Eduardo Hernández increased my interest in certain Caribbean intellectuals and artists, including Orlando Fals Borda, Gerardo Mosquera, Mercedes Angola, Wifredo Lam, and Marta Traba. Tere Perdomo, an excellent watercolorist, introduced me to art history.

Fabián Lotheau sparked my interest in Afrika and in exploring themes related to my identity. Juan Fernando Casseres led me to dream and pursue all my ideas, however crazy they seemed. The artists and poets I meet with regularly in my city, despite the fact that many of them are long deceased—Manuel Zapata Olivella, Candelario Obeso, Mina Aragon, Jorge Artel, Dorina Hernandez—are also big influences, as is Rafael Ortiz, who allowed me to accompany him on some of his projects related to the Colombian Ministry of Culture. The life and work of the humanist and activist Rafael Escallón Miranda have had a profound impact on me. Together, he and I have led RoZtro Art Collective, aimed at defending human rights, ecological rights, animal rights, etc. Ultimately, our goal is to make these groups visible through our art projects.

And what artists do you admire most?

I've been deeply affected by artists working on the anti-monument and counter-memory subjects. I admire Maya Lin for the way she found to commemorate those killed in the Vietnam War. I love Claes Oldenburg's controversial approach to public art. I adore Sol LeWitt's work, especially the simplicity of his *Black Form,* which is dedicated to the missing Jews. And I have been especially moved by Jochen Gerz, a German artist whose *Monument Against Racism* involved clandestinely engraving the names of 2,146 Jewish cemeteries on 2,146 cobblestones in front of the parliament building in the city of Saarbrücken. These non-monument monuments reflect a new aesthetic debate involving the themes of invisibility and emptiness that motivates my own work.

Nelson Fory Ferreira (b. 1986) is a video, performance, and public intervention artist who lives and works in his native Cartagena. Upon graduating from Colombia's Institución Universitaria Bellas Artes y Ciencias de Bolívar in 2009, he became an ethnoeducational professor at the Institución Educativa Arroyo de Piedra in Cartagena. As a member of the RoZtro Art Collective in Cartagena and as a solo artist, Ferreira has shown and performed his work in numerous exhibitions and events throughout Colombia, including, most recently, ¿*Suficientemente Negro? (Black Enough)* at the Centro Cultural Colombo-Americano in Bogotá in 2020.

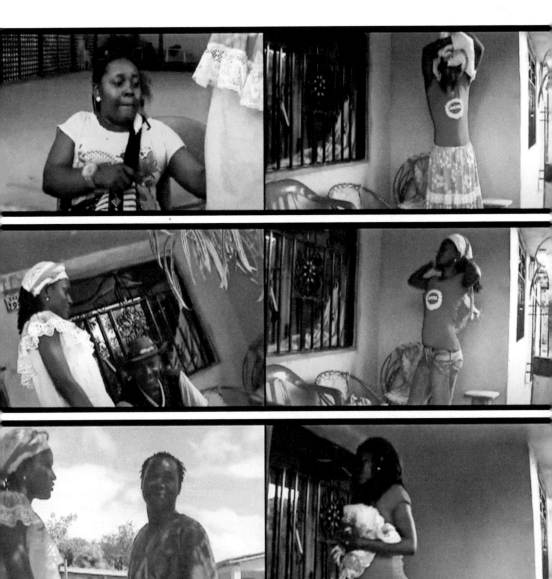

Previous pages: *¡La Historia Nuestra, Caballero!*
(Our History, Sir!), 2008–present, photographs
of two public art interventions
This spread: *El Vestier, La Changaina re Palengue*
(The Dresser, Palenquera woman), 2011, video
recording of a live performance

Madeline Jiménez Santil

In describing your practice, you've talked about being interested in the relationship "between a body as sensitive matter and geometry as an ideological structure of power." How do these interests play out in your work?

It amuses me to think that the "purity" of the traditional object can be "contaminated" by being traversed by a body with a specific history. To me, intersection is how the best objects take form. Intersection forces us to invent new things. It is the disturbance of the old that leads to something new. My embodied experience as a migrant, which takes from here and there to build its continually fluctuating identity, is similar. Perhaps that's why much of my work comes from performance. I find it hard to think about the permanence of things. For me, the object must have an intrinsic relationship with the geography it occupies. A painting by Picasso in the Caribbean should be presented in a place where you can sweat, with some nitrate at one end—or, failing that, where you can contemplate it while getting soaked in the rain.

Together with Minia Biabiany, another artist in this show, and Ulrik López, you created Semillero Caribe, an experimental artists' seminar about the theories of seminal Caribbean thinkers. How did that project connect to your larger practice?

I have a pathological need to communicate. When we developed the Semillero, I was experimenting with how to construct images of a "de-colonized" or "island" body. Living in Mexico City, I found that there was only one way my body could be understood. It involved a lot of exoticization, a lot of "color," including in the academic scene. Sharing non-European theories was a way to start building a bridge between the territory where I had decided to live and the territory I hoped to inhabit. I was trying to understand what could be common, first within the Caribbean, despite its historical and geographical fragmentation, and then between the Caribbean experience and the scene in Mexico City. The Semillero served as a kind of enunciation of where I would focus my work.

You were born in the Dominican Republic, and live and work between there and Mexico City. How does place inform you as an artist?

My work has something that disturbs in both places I live, as if it is resistant to following the established codes of either location. At first, it felt uncomfortable, living in this permanently disjointed way. Increasingly, I see it as a virtue. It has pushed me to develop my language. Of course, these processes take a long time. Mexico City moves vertiginously. When I am in Santo Domingo, I feel as if I have entered a time capsule. It has another rhythm. Then again, if the *dembow*[1] was reading this, he would raise his hand to contradict me.

In terms of the work you are showing, how would you describe your goals for this exhibition?

I am very excited by and grateful for this invitation. The project the curators have articulated is fresh and powerful. It offers the world another take on Caribbean art—one that is not insular, in contrast to the perception the outside world has had of it throughout history, but self-determined. I am honored that the curators felt my work lent itself to this project, and my response is to forge a dialogue with the space, both internally and externally, that reflects on landscape and context.

This exhibition, organized by two Caribbean curators and featuring a pan-Caribbean roster of artists, is the first of its kind in Switzerland. What impact do you think it will have on the audience in Basel?

In the past, ideas about the Caribbean have been imagined and presented by those who have had the power to do so. This exhibition intentionally puts those ideas in tension by twisting the approach from external to internal definition and by selecting a very poetic—yet provocative—title. I believe such decisions can move the point of gravity, delocalize the conditioned gaze that visitors may have to such a show. Of course, we may share in this gaze, too.

What artists, living or dead, do you most admire?

Sometimes I review the Great Men of Contemporary Art History and I talk with them—about murals, about sex, about powerful machines. This is my private joke in which I promote them to my level. On a day-to-day basis, the work of my artist friends—Carolina Fusilier, Elsa-Louise Manceaux, Adriana Minoliti, Minia Biabiany, Manuela García, Fernanda Barreto, Wendy Cabrera, Roselin Espinosa—is very important to me. We have very good discussions. But what has influenced me the most over time is an artist group that existed in Santo Domingo called Quintapata. Its members included Tony Capellán, Pascal Meccariello, Raquel Paiewonsky, Jorge Pineda, and Belkis Ramírez. I was a teenager when they were active together. I saw their performances, videos, installations, and just hallucinated. Other artists from that generation also made a big impression on me. David Pérez Karmadavis is another Dominican artist whose work has shaped mine.

1 *Dembow*, a fast-paced musical rhythm that originated in Jamaica, became widely popular as part of the reggaeton genre in the Dominican Republic and Puerto Rico, as well as across the Caribbean and beyond.

Madeline Jiménez Santil (b. 1986) is a Dominican installation artist who divides her time between Mexico City and Santo Domingo. She studied design at Altos de Chavón in the Dominican Republic and fine arts at Escuela Nacional de Artes Plásticas in Mexico City. She was commissioned for the XIV FEMSA 2020 Biennial, *Inestimable Azar*, in Michoacán, Mexico.

Previous pages: *The Construction of the Stranger,*
2019, sculptural mural with graphite, newspaper,
paper, wood, canvas, and synthetic hair
Above: *Bitch(es)|Bichos III* (detail), 2019, graphite, ink,
encaustic, chalk imprint, linen on rigid frame, and
vibrator
Opposite, top: *Notes on the First Trip in Search of Human
Merchandise or the Positive Value of the Error,* 2018,
digital print on paper with permanent ink
Opposite, bottom: *Black Paradise,* 2016, performance

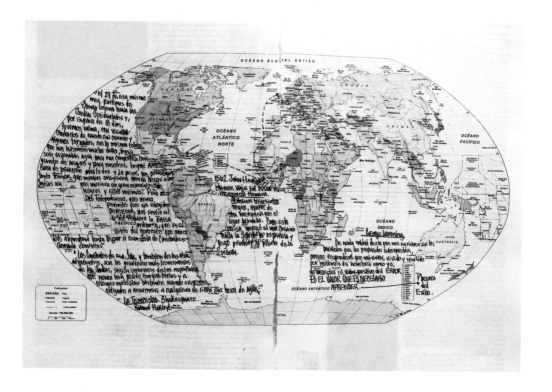

El 29 de ese mismo mes partimos de Monte Urova hacia las Indias Occidentales y, por espacio de 18 días, tuvimos calma, con viento contrarios de cuando en cuando y algunos tornados, con la misma calma que nos hicieron mucho daño, por lo solo razonable agua para una compañía tan grande de negros y para nosotros, lo que también se prestaron piratados y lo peor, no pudimos tanto tiempo, que muchos creyeron nunca llegar a las Indias, En...

1562. John Hawkins

Tessa Mars

In many of your paintings and installations, you explore the notion of carrying your homeland with you, wherever you go. How did you come to this theme, and do you see it as being particular to the Caribbean context?

I am deeply invested in understanding the "Caribbean." For me, the Caribbean is, before everything else, a gathering—a place where a certain human experience of the world is assembled. This experience is shaped by historical events near and far in time, as well as by the consequences of these events on the people and on the land. Despite the many differences in matters of language and specific narratives of self-liberation, I believe we can all identify the patterns that pertain to a Caribbean way of being in the world, whether that being is happening inside or outside the geographical limits of the region. This identification determines that space as home.

Your 2019 exhibition, *Island Template: île Modèle: Manman zile*, was certainly about such Caribbean patterns. How did it come about?

Island Template is the exploration of the island as an ideal, a frame of reference, a home. It is the exploration of the notion that a certain pattern, a code, and an alignment of ideas are immediately identifiable and recognizable and constitute the very essence of any Caribbean "land" in the absolute. Aside from the fact that this particular exploration is made through the point of view of a Haitian woman, I believe it is a truthful vision for all of us.

You created the work for that show while you were abroad. What was it like "bringing it home" to Haiti?

Many of the pieces were created outside of Haiti during various residencies across the Caribbean and in the United States. Showing them in Port-au-Prince meant confronting the "local gaze." It meant I had to face diverging opinions and the question of whether my ideas would hold up to the scrutiny.

Tessalines, your long-running fictional alter ego, is the determined, defiant, and certainly heroic gender-bent fictional version of Haiti's national hero, Jean-Jacques Dessalines. Is her defiance your form of protest? Or, to put it another way, what does revolution mean to you?

When I think of revolution, I think of change, but specifically change in how you perceive yourself after a change in how you position yourself. A revolution can take many shapes and forms. For me, it's bound up in violence and sacrifice, even when those are quiet and not obviously physical.

With Tessalines I was answering a call in myself for a change in how I see myself and how others see me. I wanted to manifest a certain ease and freedom and power. Through Tessalines I tell stories first to myself, then re-invent and retell them. These are stories of real-life experiences with real voices—often female voices—that are silenced and unheard.

How does this personal expression of protest intersect with the current political situation?

The Haitian Revolution officially happened two hundred years ago. But I would say it is still happening, in that its consequences are still affecting us. It still has lessons to teach across borders, islands, and continents. There are still stories to be told and studied, particularly the feminine experience of the revolution.

With two Caribbean curators and a cross section of the Caribbean represented as artists, this exhibition, *One month after being known in that island*, is the first of its kind in Basel. As a participant, what goals do you have for this show? What sort of impact do you foresee it having on Basel?

I did a lot of research for this show. I reviewed the Treaty of Basel of 1795, and then took myself through the very unpleasant exercise of thinking myself back to that time. Conversely, I also attempted to bring that past to the present and find my place in it now. This practice is a solitary one, in that I'm engaging with a text and with ideas about people, but in the absence of those people.

My hope is that the exhibition in Basel leads to rich conversations between the work and the audience, that it suffuses local energies with the different Caribbean thoughts and perspectives represented, and that it makes space for the establishment of new relations and new opportunities for reflection.

What artists, living or dead, have been most influential on your artistic practice?

I look up to many artists whose work I find compelling and whose ideas invoke a feeling of kinship. These people come from different continents and different practices. One artist I deeply respect and look to when in need of advice is Christopher Cozier, from Trinidad. His work has helped shape the ways in which I think of the Caribbean. He is a very generous person who has contributed to the growth of many a young artist from the region. Hopefully, he feels nourished by his conversations with us, too.

Tessa Mars (b. 1985) is a visual artist who lives and works in her native Port-au-Prince, Haiti. She completed her bachelor's degree in visual arts at Université Rennes II Haute Bretagne, in France, in 2006, and then served as cultural projects coordinator at Fondation AfricAméricA, a Port-au-Prince organization dedicated to supporting contemporary Haitian artists. Since 2013 she has been solely focused on making art. In 2017, she was a Davidoff Art and Initiative awardee. Her work has been exhibited in Haiti, Canada, France, Italy, and the United States; and is part of the permanent collection of the Musée d'Art Contemporain de Baie-Saint-Paul, Haiti.

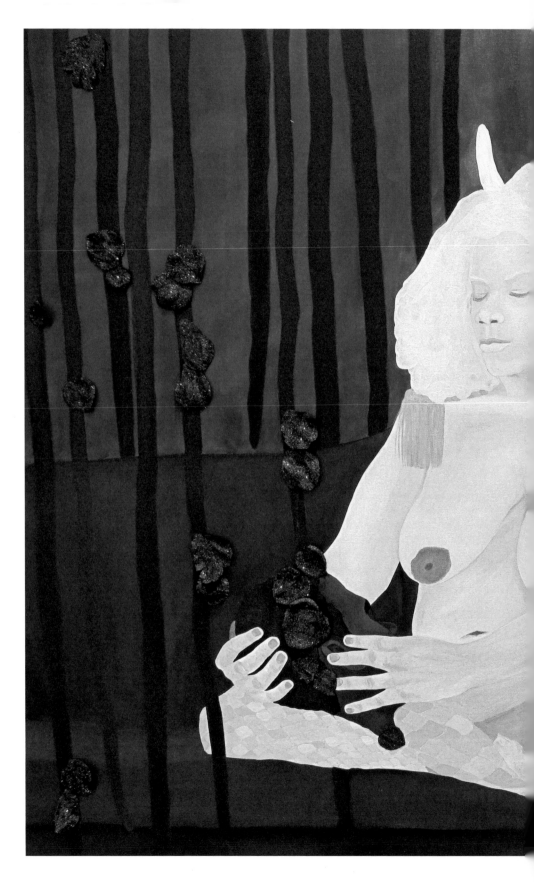

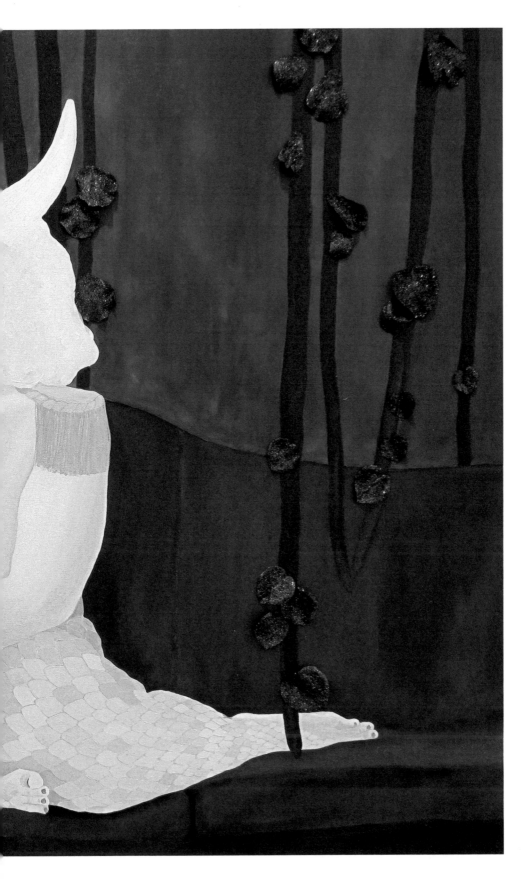

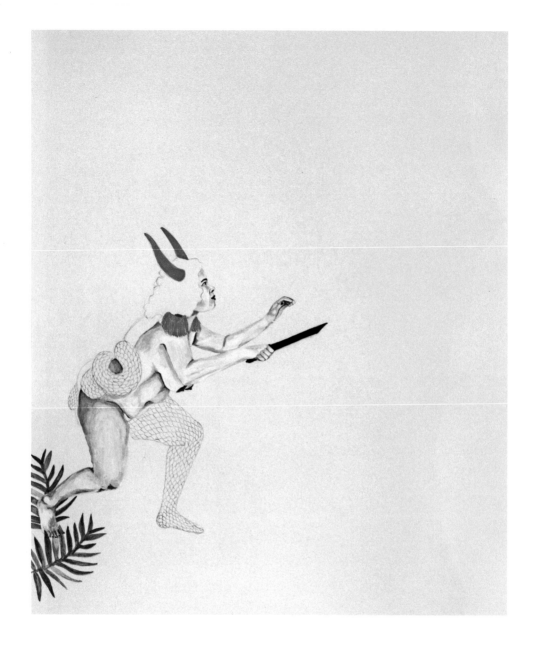

Previous pages: *Goddess of Memory,* 2018, acrylic
and fabric on canvas
Above: *The Good Fight II,* 2018, acrylic on paper
Opposite: *Marie Thérèse et Dieunie,* 2019,
acrylic on canvas

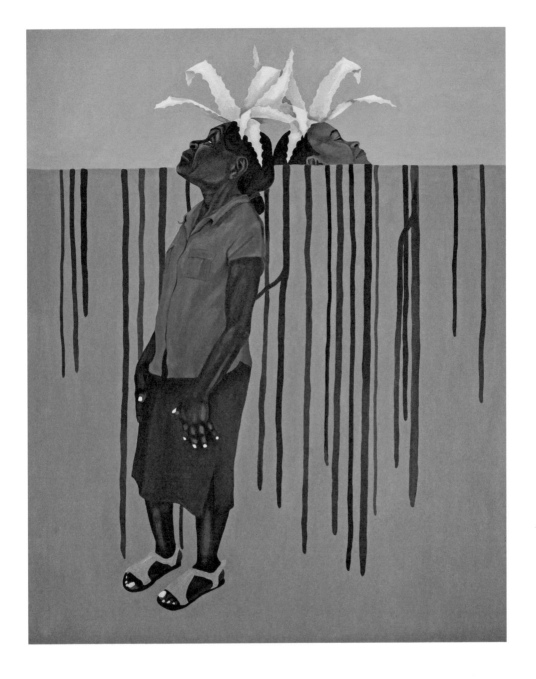

Ramón Miranda Beltrán

How did this exhibition's thematic connection to the Treaty of Basel shape the work you are showing?

I have long been interested in historical archives. In preparation for this exhibition, I decided to read all the historic documents related to the Treaty of Basel, which the curators are referencing with this show.

Is your practice generally motivated by historical documentation?

Starting with archival material is an approach I've taken in the past. But sometimes I take an opposite approach, in which the form comes first and only later do I associate that form with an event. For *Puerto Rican Youth,* I placed a stack of twelve concrete slabs memorializing the articles published by the *Chicago Tribune* about the Division Street riots on Division Street, where the riots happened. It was the documents that suggested the form of square slabs that mounted up into cubes. In the case of *sujeto/objeto,* my 2016 mixed-media series about the relationship between the materials

and forms of our built environment and the ways those forms structure the relation between subject and territory, the pieces themselves suggested forms from images of the Haitian and French revolutions.

***sujeto/objeto,* like much of your past work, is designed to occupy and "activate" the space it inhabits. How do you conceive such occupations?**

In the case of *sujeto/objeto,* it was important to me to use the endemic woods of Puerto Rico. And I was lucky that I was working at MAOF [Materiales y Oficios, a temporary lab of Beta-Local managed by a collective also named MAOF], because the organization sources local materials. The team there helped me find a particular wood in sawmills around the island. And since I was in a workshop that was constantly bringing in wood, it all happened organically—the material started calling me. Once that process begins, one has only to pay attention as the material reveals its form. This is what I meant when I said earlier that

in *sujeto/objeto* the form came first. I had been taking photographs of places I needed to be in to understand what the Puerto Rican state was trying to bring in through tax-haven laws. At the same time, I was experimenting with materials at MAOF. The sculptures came from working with cement and wood. Later, I put them in a context of ideas about territory and revolution. That show was a response to the experience of looking at the constructed landscape from the luxury apartments and office spaces in San Juan.

Your practice involves making and working with artist books. How did you get interested in this form? Is there a tradition of artist books in the Caribbean?

My MFA was in the printmaking department at the School of the Art Institute of Chicago. It was there that I learned how to operate an off-set press. I was a teaching assistant for Alex Valentine, who organizes the Chicago Book Fair and the Yale School of Art print shop. My roommate, Brian Rush, had just started No Rush Press. And Yuchen Chan, who has made a lot of great artist books, become a good friend. So I was around a lot of book people, but I had never made one until *H-AS OS*, which I made to accompany *sujeto/objeto*. It came so naturally and easily that I definitely want to make more. Right now, I am making one for my next solo show, with text from artist Javier Fresneda. I have no idea what its final form will be. I am still seeing how it evolves. Also, there is a rich history of artist-run presses in Puerto Rico; I've been close to La Impresora, which was originally based at MAOF and printed my book, *H-AS OS*, on their Risograph machine.

Beyond the bookmakers you mentioned, what artists—living or dead—have been most influential on your practice?

Tony Cruz Pabón, Las Nietas de Nonó, Beatriz Santiago Muñoz, Pablo Guardiola, Diego de la Cruz Gaitán from the collective MAOF, and I have started working together for feedback and mutual aid. This group, of which I am very proud to be a member, has been the biggest influence on my work recently.

This is the first exhibition of its kind in Switzerland. What impact do you think Caribbean work curated by Caribbean curators on a very Caribbean theme will have in Basel?

I really do not know the context of Basel. I can only hope the show will be meaningful and enlightening for all who see it. What I can say is that the environment is set for the best representation of the work, given the specific group of people organizing and participating in this show and the circumstances in which the work will be presented.

Ramón Miranda Beltrán (b. 1982), a multi-disciplinary artist whose work uses the materials and forms of our built environment, lives and works in his native San Juan, Puerto Rico. After majoring in fine arts at the Universidad de Puerto Rico, he earned an MFA from the School of the Art Institute of Chicago. He is the recipient of a 2019 Pollock Krasner Foundation grant and a 2017 Joan Mitchell Foundation grant. His work has been exhibited in Europe, the United States, the Caribbean, and Latin America.

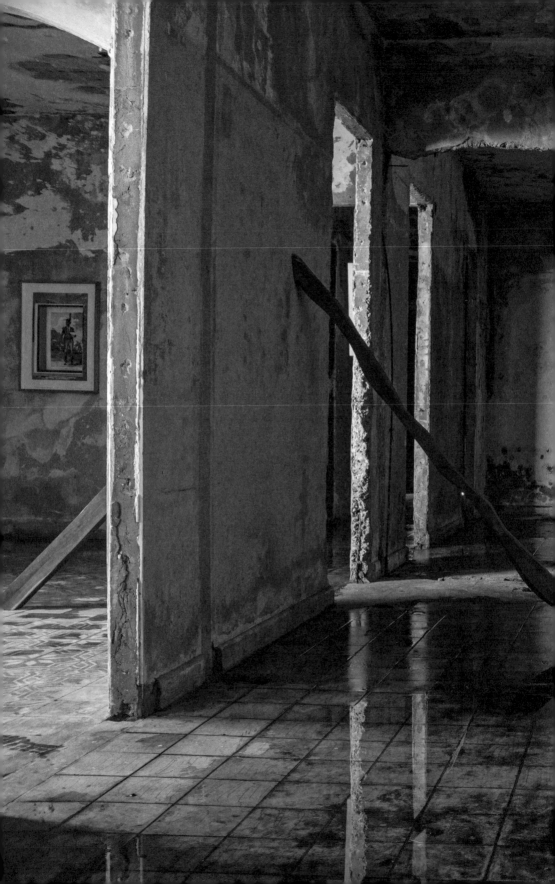

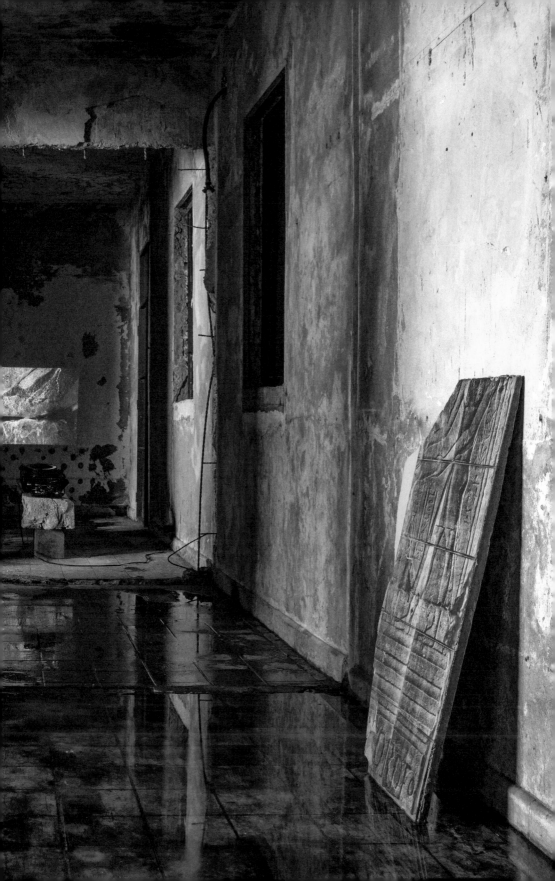

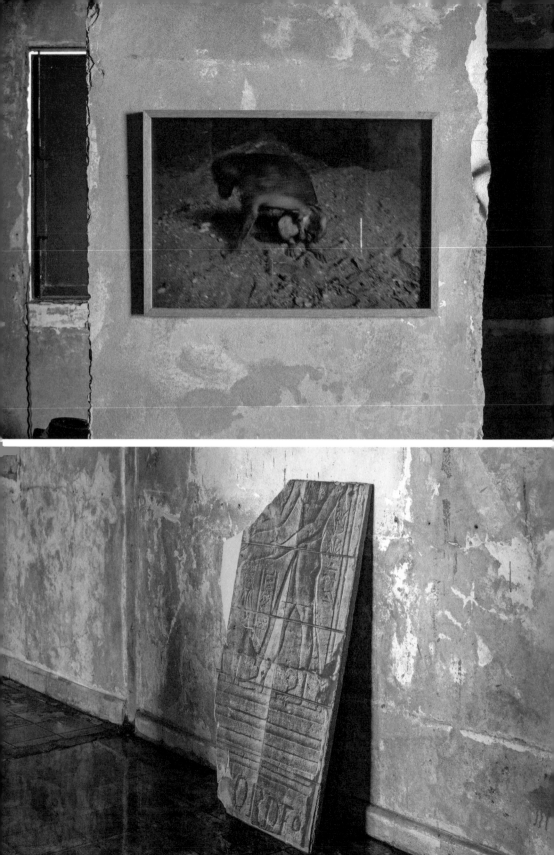

Previous pages: *Antro (Common),* 2020, installation;
Photograph by Ramiro Chaves
Opposite, top: *Cave Dog,* 2020, inkjet print on archival
cotton rag
Opposite, bottom: *Graffiti on Displaced Temple,* 2020,
photo-transfer on cement
Above: *H AS-OS (detail),* 2016, Risograph-printed
artist book

José Morbán

Your practice, specifically your *Dominican Dreams* series from 2010 to 2018, is rooted in collective historical memory and focused on the city in which you live, Santo Domingo. How does where you're from inform and influence your work?

Santo Domingo—the Dominican Republic in general—is a deeply chaotic place. It is full of inequality and missed opportunities. For example, this is a place that, although it is surrounded by water, doesn't have a clean public beach. That's why the horizon is one of the recurrent elements in my work. Its endlessness evokes a sense of longing that most Dominicans feel. It is a reminder of the urge to escape. Currently, about fifty percent of Dominican youth think or have thought about migrating. Although some of the *Dominican Dreams* paintings hint at particular places of the city, I prefer not to reveal them entirely, because I think the artwork has to have a universality to it and not be attached to any specific site.

Whether it appears literally, is alluded to, or figures in the background, the sea is a big theme running through your work—as it is for so many Caribbean artists. How do you think it will translate in Basel, which is landlocked by mountains? Do you feel there is some common ground there, for visitors to engage with your work?

I've never met a Swiss person before. Hell, I've never even been to Europe. So for me to try to understand what a place like that is, is sort of unnerving. I could tell you that every place has its limits, an endpoint if you will, where one might feel one's insignificance in relation to nature. Maybe for the Caribbeans it is the sea, and for the Swiss it is the mountains, and for the Russians it is the coldness of Siberia?

One month after being known in that island will be the first exhibition in Switzerland organized by two curators from the Caribbean that features a pan-Caribbean group of artists. What are your goals for this show, and what impact do you foresee it having on visitors?

I don't think I'm quite grasping the repercussions of this project. And I prefer not to overthink it so that I don't get anxious. Since

[curator] Yina [Jiménez Suriel] and I have known each other for some time, we have trust in each other's work. I can't speak to the impact of the exhibition, since the times we live in are confusing. How could we measure something like impact? Through likes and comments on Instagram? Through media coverage of the so-called center? I just hope that what is shown can help to widen the understanding of what Caribbean art is.

There is a lot of found imagery in your work, such as the newspaper photos of the 1984 protests in the Dominican Republic in your *Palo Acechao* series, and the images of uniforms and masculinity in *Dominican Dreams*. What inspired you to incorporate this kind of material in your practice? How do you source it?

I have countless images in my laptop, a personal archive where I go to find references for new works whenever I feel like I've reached a dead end. For *Dominican Dreams* I started with images I found in a discarded family album. I then moved on to historical photos, which pushed me to broaden my research to books, the internet, and newspapers. *Dominican Dreams* and *Palo Acechao* are two intertwined series. While doing the research for *Dominican Dreams* I visited the National Archives several times. That research led me to the protest pictures of 1984. I instantly knew I would work with those photos, but not in a painterly way. Thinking of visual poetry, I wanted to use them to create something reminiscent of the Latin American visual poets of the '60s through '80s—such as Clemente Padín and Wlademir Dias-Pino—whose poetry was an act of resistance to dictatorships. In those decades, artwork sent via mail helped network dissident voices of the regimes in the continental south. Because newspaper images are always accompanied by text, I decided to retain a tabloid format similar to the newspapers for *Palo Acechao*. I used transfer paper to retain the look and feel of the original, even after I had reconstructed the accompanying messages.

What artists—living or dead—have been most influential on your practice?

I have a close group of artist friends—Julianny Ariza, Joiri Minaya, Javier María, and Engel Leonardo—whose practices I admire.

They have helped me grow as an artist because I've seen up close the effort they've put into their work throughout the years. With them, I talk endlessly about art and what it means to be an artist, especially one from the periphery. Of course, as an art student and curious person, you see and learn through the work of so many artists. Some established artists I've followed through my career are Luis Camnitzer, whose written work has helped me to define my own practice, and Luc Tuymans, a painter who deals with historic tropes and found imagery.

José Morbán (b. 1987) is a painter and graphic illustrator who lives and works in his native Santo Domingo. He studied fine arts first at the Escuela Nacional de Artes Visuales in Santo Domingo and then both fine arts and illustration at School of Design at Altos de Chavón in La Romana, Dominican Republic. His recent exhibitions include *Dominican Dreams* at Casa Quién, Santo Domingo; and *Concurso de Arte Eduardo León Jiménes* at Centro León, Santiago de los Caballeros, Dominican Republic.

El Nacional

Santo Domingo, República Dominicana, Lunes, 23 de Abril de 1984

se extendían como reguero de pólvora a calles y barrios adyacentes.

4/5

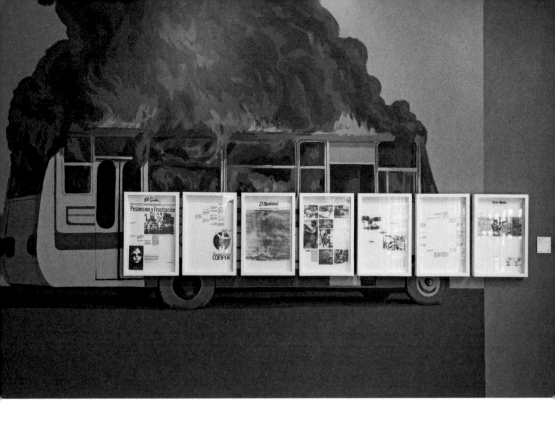

Page 110: *Elecciones (Elections),* 1996, oil on canvas
Page 111: *Lacrimosa (Sorrow),* 2017, oil on canvas
Opposite: *Palo Acechao 1984 (Surprise Attack),* 2018,
Xerox transfer on paper and painting on wall
Above: *Dominican Dreams,* 2018, mixed-media
installation

113

Guy Régis Jr.

How would you describe the work you are showing in this exhibition?

It is a sound piece based on a treaty. Sound is a medium I have been using more and more recently. Recently, I produced *Mr. President,* which I would describe as a poetic, aesthetic video. But I always work with a range of different media. For me, the different arts offer different means of expression. I don't see them hierarchically. There is not one form that I consider to be higher or lower than another. There are just various channels for conveying my feelings and ideas. Through writing, I become a creator of ideas. An image can intervene to show that idea. And theater allows me to embody the idea in the present. It is, therefore, not at all a derogation to present this work as something to which we all must listen. I could have brought it face-to-face on a stage, or in video creation, etc. Sound was the form that felt right for this particular expression.

In your truly interdisciplinary practice—you are a theater director, playwright, poet, author, filmmaker, video artist—you work with many creative people and with the community at large. What do collaboration and engagement mean to you?

For twenty years, I have been a stage director. Theater work involves a collective, the active participation of others as a group. It involves exchanges with actors, technicians, audiences. I need collaboration—a real, personal implication by each individual in all activities—from everyone to make it succeed. As for engagement, I see it as the foundation of all art. It's fundamental. I create to make a statement, to affirm, to denounce, to describe the world around me. If I weren't engaged with the world, I would not create. It would not be necessary. An artist is engaged from the moment he makes the decision to create. And for me, engaging with other creatives and with the broader community is about questioning the notion of whether art is useful. The world can be hostile to artists. Artists are disparaged,

considered futile or fanciful by some. By collaborating with other creatives and with the broader community, we build unity in showing the value of art in this capitalist world that seems so interested in material goods.

How does Port-au-Prince, where you live, define or inform your practice?

I prefer to write when I am away from home, because there are fewer distractions. I've benefited greatly from the time I've spent in residencies far from my turbulent life in the Haitian capital, where I am responsible for running an annual art festival called Quatre Chemins. But the loneliness is unbearable. Sometimes, I can really immerse myself in my creation when I am in Haiti. These are rare, blessed moments. At home, I like to be with the others; that's why I create theater—to work with others.

You've described Quatre Chemins as an organization that builds cultural infrastructure in Haiti. Why is that so important in your country?

I believe art is like a little lifeline that can help pull us up from the abyss, or out from the cave. Most of the people in Haiti are under twenty. They need to be trained if we want a better tomorrow. Art can be a big part of that. I was fortunate to have had a certain journey, despite all the lack and the pitfalls, that led me to art and to a broader sense of the world. Now that I'm at a certain age, it is obvious to me that I need to share the good experiences that I've had and to help encourage the next generation.

Do you have specific goals or expectations for this exhibition?

My hope is that this exhibition will show the old world, or what we think of as the colonial world, which is often so distant, the diversity of Caribbean cultural creation. I'm excited that my small contribution can be part of this great diversity.

What artists, living or dead, have most influenced your artistic practice?

Frankétienne comes into my mind. His creative force has always impressed me. For Frank, creation is multifaceted—he writes, he paints, he makes music. But whatever he is creating, it is above all about truths, big truths. Seeing his work often enables me to believe deeply—and to stay committed to—the work I am doing today. Another important influence is Syto Cavé, a major poet and unique human being. For him, nothing needs to be laborious to be worthwhile. His focus is on the goodness of what is most simple and elemental in the world. His attitude is always, "Come on, let's give it a try!" His work is the Holy Grail of poetry for me. And I feel the same way about the work of Marie Chauvet. How could one write like she did? So perfect, so true? In cinema, Andrei Tarkovsky is a demigod for me. Tarkovsky taught me to love Robert Bresson, whom he admired greatly. And there are numerous others! So many auteurs have shaped my thinking and guided my way.

Guy Régis Jr. (b. 1974), an award-winning director, playwright, actor, poet, and video artist, was raised in Liancourt, in the north of Haiti, and now lives in Port-au-Prince. In 2001, he founded Nous Theatre, a contemporary experimental Haitian performance company. Between 2012 and 2013, with the support of the European Union, he directed *Migrants*, a series of large-scale artistic workshops throughout Haiti with international creators. From 2012 to 2014, he was the director of drama at the National Arts School of Haiti. He now serves as executive director of Association Quatre Chemins, an organization that aims to renew and develop Haiti's living arts through an annual theater festival, artistic residency programs for drama outside the boundaries of Port-au-Prince, and programs focused on children's and students' access to drama throughout Haiti. Régis's plays, novels, and theater works have been translated into multiple languages and have toured internationally.

Trete pou lapè lavi diran

Ant: Wa a ki se chèf senyè nou
Avèk: Repiblik Lafrans
Siyen nan vil Basilea 22 jiyè 1795

Wa a, ki se chèf senyè nou, e ki jiskasetè t ap mennen yon batay san pitye ki te koute chè anpil, pou te ka rive mete lapè sou teritwa tout sijè I yo, finalman kontan li fin pa mete bout nan batay la, jan I te swete sa rive, selon tout presizyon Son Ekselans lan te bay Plenipotansyè li limenm, aprè yon egzamen byen long dosye a, ki byen rapòte nan nouvo Trete sa a, nan lide sa a pibliksayon sa a fèt, pou tout sijè yo ka konnen I byen, pou yo ka rekonfòte lè yo tande nouvèl la.

Samajeste Wa Espay, epi Repiblik Fransè a, toulede gen menm santiman ki anime yo pou yo kanpe tobout kalimite lagè ki te vin divize yo, yo tou tonbe dakò lapoula, sou rezon ki fè toulede nasyon yo gen anpil entère pou yo ta retounen vin zanmi an bon entèlijans, e puiske yo vle, ak bon jan lapè solid e ki dire, mete sou pye amoni ki te depi tout tan baz toude peyi yo, yo bay pou responsab Negosiyasyon enpòtan sa a ; an pèsòn menm, Samasjeste Katolik, Minis Plenipotansyè e anvwaye spesyal Ekstraòdinè bò kote pa Wa a, ak Repiblik Polòy, D. Dominguo de Yriarte, Chevalye Lòd Wayal Charles III, e Co. E pou Repiblik Franswaz sitwayen François Barthelemy, anbasadè li Lasuis, ansanm aprè yon fin fè konesans, prezante yo selon grad yo, yo te deside pran arete sa yo ki pral suiv la a :

I

Lapè deklare an tout entèlijans, ant Wa Espay, ak Repiblik Fransè a.

II

Pou rezon sila a, tout ingang ant de puisans sa yo, ki siyen akò sa a ap kanpe, a konte jou echanj Ratifikasyon Trete sa a lapoula, ankenn nan yo de a pa gen dwa nan menm tan n ap pale a, founi yon pyès kont lòt, kelkeswa jan sa ta ye, e a nenpòt ki tit, ankenn sekou ni kontenjan, keseswa a pye, a cheval, ak manje, minisyon pou lagè, sijè oubyen lòt jan I ta ye.

III

Yo pa gen dwa bay lenmi yonn oubyen lòt pasaj sou teritwa pa yo.

IV

Repiblik Franswaz ap remèt li tout byen li te sezi pandan konkèt li te fè pandan lagè nan epòk sa a. Tout sipèfisi epi peyi li te mete lamen sou yo, twoup fransè yo ap kite yo, kenz jou aprè Ratifikasyon Trete a.

V

Sipèfisi pou sede a Espay ki te site deja nan atik ki anvan nan Trete a, avèk kanno, minisyon pou lagè, tout lòt eleman ki itilize nan sipèfisi sa a, e ki egziste nan moman n ap siyen akò sa a.

VI

Tout kontribisyon, livrezon, founiti, ak prestasyon pou lagè a, dwe fini kanpe tobout apati kenz jou aprè siyati pasifikasyon sa a. Tout montan dèt ki te dwe jiska epòk sa a, ni tout biyè lajan, pwomès ki te bay, oubyen ki te reyalize, ap vin pa gen ankenn valè ankò. Tout trazaksyon ki pral fèt aprè peryòd la dwe fèt gratis, oubyen ak lajan kontan.

VII

Chak pati konsène yo ap nonmen yon komisè ki ap la pou mete sou pye yon Trete pou fikse limit chak nan de Puisans yo. Y ap pran pou baz nouvo Trete sa a jan sa posib, nan pran tan mezire teren yo te livre batay anvan lagè epòk sa a, krèt mòn ki te fòme vèsan dlo pou desann swa an Espay, oubyen Lafrans.

VIII

Chak nan Puisans ki fin siyen kontra sa a, yon mwa aprè li fin fè echanj siyati Ratifikasyon Trete sa a, ap gen dwa pou konsève sèlman nonb sòlda li te konn genyen la deja anvan lagè sa a te vin eklate.

IX

An echanj ak restitisyon ki pote nan atik katriyèm nan, Wa Espay nan, pou limenm, pou siksesè I yo, sede e abandone viteprese pou Repiblik Franswaz la tout pati Espanyòl zile Sen Domeng ki Ozantiy yo.

Yon mwa aprè Ratifikasyon nouvo Trete sa a fin rekonèt nan zile sa a, tout twoup Espanyòl yo dwe mete yo prè pou yo kite lapoula plas yo, tout pò, ak tout etablisman yo te okipe, pou remèt yo bay Twoup Repiblik Franswaz, lapoula nan moman yo prezante devan yo pou reklame yo vin pran posesyon yo. Tout sipèfisi, Pò, ak etablisman sa yo ki te site anlè a, y ap remèt yo bay Repiblik Franswaz yo, ak kanno, minisyon pou lagè, ak tout lòt zafè ki nesesè pou defans yo, e ki egziste ankò, jou pou jou lè Trete sa a rive Sen Domeng.

Abitan pati Espanyòl la, pou motif enterè pa yo, oubyen lòt rezon, ki ta prefere transpòte yo ak byen yo, sou lòt tè ki anba men Samajeste Katolik Espay, ap ka fè sa nan lespas yon lane, akonte dat Trete sa a.

Chak Jeneral ak Kòmandan de nasyon yo ap konsète ansanm sou ki mezi, ki pou pran, pou egzekisyon nouvo atik sa a.

X

Y ap akòde pou chak grenn moun nan de nasyon yo, yon men leve, sou zafè yo, avwa yo, sa yo te pran, te sezi oubyen vòlè nan men yo, akoz lagè ki te genyen ant Samajeste Katolik ak Repiblik Franswaz, an menm tan ap genyen tou jistis san pas pouki, pou kelkelanswa dèt, moun sa yo ta genyen, nan de Puisans sa yo ki fin siyen akò sa a.

XI

An antandan gen yon nouvo Trete Komès ant pati ki kontrakte yo, alawonnbadè, tout kominikasyon, ak relasyon komèsyal ap reetabli ant Espay ak Lafrans, menm jan yo te ye anvan nouvo lagè sa a te deklare.

L ap libelibè pou tout negosyan espanyòl reprann, epi replase etablisman yo nan Lafrans, oubyen rekreye nouvo, jan yo vle, nan ka sa a y ap nik soumèt yo toukou tout lòt moun, anba menm lwa ak izaj peyi a.

Negosyan fransè yo ap ka jui menm lwa ak izaj sa yo an Espay, nan menm kondisyon yo.

XII

Tout prizonye tou de bò yo, ki te nan depo depi kòmansman lagè a, san kesyon valè ni ki grad yo ta ye, kit li ta maren, matlo, sijè Espanyòl oubyen Franswa, oubyen lòt nasyon, oubyen lòt kalte moun ki ta anprizone ankò, nan tou de bò yo, pandan espas tan lagè sa a, dwe libere anvan de mwa pou pita, aprè echanj nouvo Trete sa a, san sa pa bezwen repete, dwe gen ankò tou de bò yo, toutfwa yo gen pou peye tout dèt yo te kontrakte pandan tan anprizonman yo. Se menm posede a k ap fèt tou pou malad ak blese yo lapoula aprè gerizon yo.

N ap nonmen san pran tan Komisè tou de bò yo, ki ap la pou fè respekte nouvo atik sa a.

XIII

Prizonzye pòtigè yo ki te fè pati twoup pòtigè ki te sèvi ak lame epi sijè Samajeste Katolik, yo tou yo konsène nan echanj nou te fè ka anvan an. Menm resipwosite a tou ap tabli pou fransè twoup pòtigè sa yo n ap pale a te rive met men sou yo.

XIV

Menm lapè sa a, ak menm lamitye sa a, an tout entèlijans, ki ekri nan nouvo Trete a, ant Wa Espay ak Lafrans, dwe tabli l ant Wa Espay ak Repiblik tout lòt pwovens ki alye yo ak Repiblik Franswaz la tou.

XV

Repiblik Franswaz, nan volonte l pou l temwanye lamitye ak Samajeste Katolik, aksepte fè medyasyon an favè Larèn Pòtigal, Wa Napoli, Wa Sardèn, Enfant Dik de Pam, ak lòt Leta Italyen, pou reetablisman lapè ant Repiblik Franswaz, ak chak grenn Prens li, ak Leta li yo.

XVI

Repiblik Franswaz ki rekonèt enterè Samajeste Katolik la genyen pou pasifikasyon jeneral fini pa renye an Ewòp, konsanti pou akeyi kote pa li, tout demach an favè lòt puisans ki nan batay yo tou, ki ta vle adrese yo ak Samajeste a pou ta rantre nan negosiyasyon ak gouvènman Franswaz la.

XVII

Nouvo Trete sa a ap gen bon jan efè lè l fin pa Ratifye anba paraf toude pati ki kontrakte l yo, e echanj Ratifikasyon yo gen yon mwa pou rive a tèm, osnon si sa posib apati jodi a menm.

Ak tout lafwa nou e pa respè pou nòt sa a, Nou menm, ki siyen anba l, Plenipotansyè Samajeste Wa Espay ak Repiblik Franswaz, an kalite tout pouvwa nou genyen pou sa, nou siyen nouvo Trete pou lapè ak lamitye sa a, e nou fè poze so nou chak anba li.

Sa fèt Bal 22 jiyè mil sèt san katreven kenz (katòz tèmidò an twazyèm Repiblik Franswaz).

(L.S.) Domingo de Yriarte
(L.S.) François Barthelemy

Previous pages: The Treaty of Basel translated
into Haïtian Créole by Guy Régis Jr.
Above: *De Toute La Terre Le Grand Effarement
(And the Whole World Quakes, The Great Collapse)*,
2012, sound installation; Photograph by
Marie-Agnès Sevestre
Opposite, top and bottom: *Dezafi*, 2015, photographs
of theatrical adaptation of Frankétienne's novel directed
by Régis Jr.; Photograph by Violette Graveline

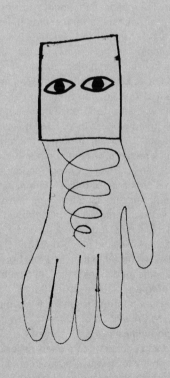

THE CARIBBEAN ART INITIATIVE

The Caribbean Art Initiative (CAI), established in 2019, is an independent, non-commercial program and network that aims to foster the development of arts and culture across the entire Caribbean region. Under the direction of Albertine Kopp and with the active support of artistic advisor Pablo León de la Barra and strategic advisor András Szántó, CAI focuses on raising awareness and understanding of the arts and culture of the Caribbean region by placing Caribbean art and artists—as well as Caribbean curators, writers, and educators—in open and active dialogue with creative peers and institutions around the world.

From its inception, the initiative's intent has been to mount exhibitions that provide encompassing views of noteworthy art being made in and about the Caribbean today, in particular by regionally based artists who are addressing critically relevant issues in the contemporary international art world, and who have thus far been underrepresented in international art exhibitions and dialogues.

One month after being known in that island is CAI's first exhibition project and the first exhibition of its kind in Switzerland. The curatorial team of Yina Jiménez Suriel and Pablo Guardiola was selected from a competitive, open-call juried process in 2019 that was limited to curators living or born in the region with a track record of writing about and curating Caribbean art. Their proposal responded to CAI's vision for an exhibition comprising new, loaned, and site-specific works that situates the work of contemporary Caribbean artists in a historical framework around a compelling, accessible, and timely theme.

Producing the exhibition, and this book, adds a significant dimension to CAI's multifaceted program of artist-in-residency exchanges, events, and research. It is a major step toward CAI's goals of fostering new creative opportunities for Caribbean arts around the world and encouraging a deep, salient dialogue on the topic with a broad international public. Additional information about CAI, including how to support its future programs, is available at www.caribbean.art.

THE KULTURSTIFTUNG BASEL H.GEIGER

The Kulturstiftung Basel H.Geiger (KBH.G) was established in 2018 for the purpose of organizing exhibitions in Basel on various cultural themes. Founder Sibylle Piermattei Geiger's intention is to provide exhibitions free of charge, so that they may be easily accessible to a broad public. To have a sustainable and lasting effect, visitors will receive a free catalogue, further elaborating the theme of the respective exhibition. The foundation's premises are located in the heart of the city of Basel. Former cultural journalist Raphael Suter serves as the foundation's director. Additional information about KBH.G is available at www.kbhg.ch.

THE AUTHORS

Marta Aponte Alsina is a Puerto Rican writer and scholar. In addition to publishing novels, short stories, criticism, and a book of essays, she has served as director of two of the island's main publishing houses, the Institute of Puerto Rican Culture Press and the University of Puerto Rico Press. Her scholarly and creative works, which have been translated into Italian, French, and English, embrace a literature of connecting histories, relating the Puerto Rican experience to Caribbean and North American contexts. In 2015 she was honored with the Nilita Vientós Gaston Chair by the Programa de Estudios de Mujer y Género of the University of Puerto Rico. And in 2018, she was named one of the twelve essential Spanish-language female authors in *Publishers Weekly*.

Rita Indiana, a Dominican-born, Puerto Rico–based writer and singer-songwriter, is the author of five novels, the lead singer of Rita Indiana y Los Misterios, and a driving force in experimental Dominican popular music. In 2011, she was selected by the newspaper *El País* as one of the "100 most influential Latino personalities." Her novel, *La Mucama de Omicunlé (Tentacle)*, won the Grand Prize of the Association of Caribbean Writers in 2017, the first Spanish-language book to earn that honor. In the Dominican Republic she is popularly referred to as "La Montra" (The Monster).

THE CURATORS

Yina Jiménez Suriel is a researcher and architect who lives and works in the Dominican Republic. She obtained her master's degree in art history and visual culture from the Universitat de València, Spain. As part of the master's program, she interned in the curatorial department of the Museo de Arte Moderno de Medellín, serving as a curatorial assistant for the exhibition *Contrarelatos en la Colección MAMM*. An alumnus of the Curando Caribe curatorial studies program, she was associate curator for the 26 Eduardo León Jimenes Art Contest hosted by Centro León, an art and cultural organization in Santiago de los Caballeros. From 2017 to 2018, she worked as a curator in Casa Quien, an artistic production space in Santo Domingo. Currently, she is developing research for *Women and Architectural Space in the Dominican Republic: Domestic Revolution, Public History* with Eva Álvarez in collaboration with the Universitat Politècnica de València and the magazine *Arquitexto*. Since 2018, she has been a curator at Centro León, where she develops new strategies for using visuals to interpret and share Dominican social history.

Pablo Guardiola is a visual artist whose practice involves objects, photography, and writing. His prime interest is the production of various modes of reading and narration, as well as how those modes are perceived and interpreted. Guardiola, who lives and works in San Juan, Puerto Rico, earned his bachelor's degree in history from the University of Puerto Rico (Río Piedras) and a master's degree in fine arts from the San Francisco Arts Institute. His work has been exhibited in San Francisco at numerous galleries and at the San Francisco Arts Commission; and in Puerto Rico at El Lobi in Santurce. In 2009, he received a commission from the Cultural Equity Office of the San Francisco Arts Commission. In 2012, he was awarded grants from Southern Exposure's Alternative Exposure and the Creative Capacity Fund, both in San Francisco. In 2019, he received a grant from the Flamboyán Foundation, in association with the National Association of Latin Arts and Cultures and the Flamboyán Arts Fund. Since 2013, he has been the co-director of Beta-Local, a San Juan–based arts nonprofit that supports art practices and critical thinking in Puerto Rico.

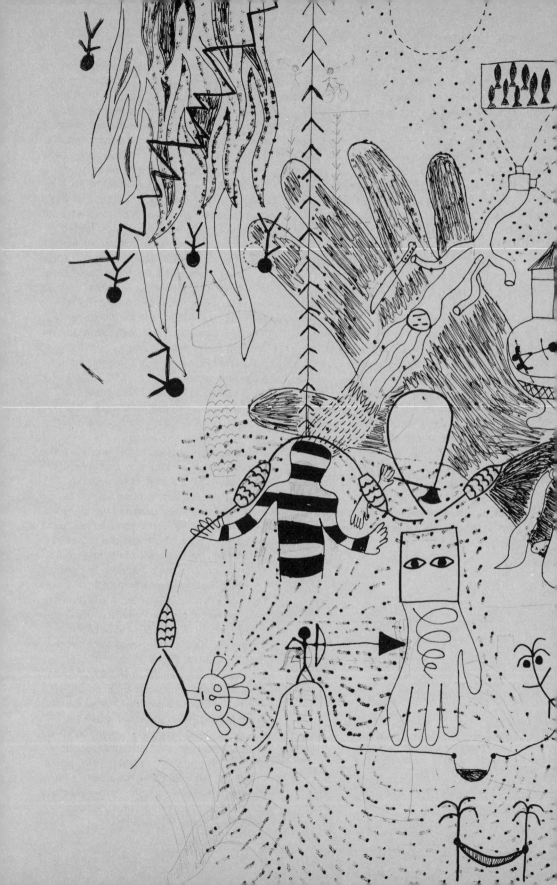

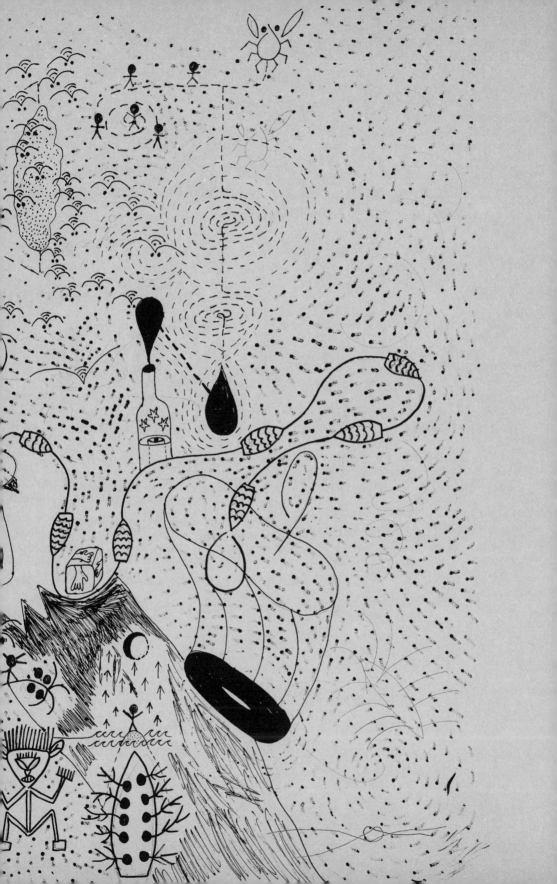

ACKNOWLEDGMENTS

This book is a celebration of several firsts—the Caribbean Art Initiative's premiere exhibition, the inaugural show of the Kulturstiftung Basel H.Geiger, Switzerland, and the first group show of contemporary Caribbean artists in Basel. Our thanks go to the curators, Yina Jiménez Suriel and Pablo Guardiola, who worked together across borders and oceans—as well as through a pandemic—to assemble an amazing array of work from the region and its diaspora for the benefit of a global audience.

We are especially indebted to the eleven artists in this project, who hail from nine different locations across the wider Caribbean region and contributed not only their engaging artworks but also their thoughtful answers to probing interview questions, which are included here and online at caribbean.art as a series of Q&As.

We are grateful, too, to writers Marta Aponte Alsina and Rita Indiana, whose incisive essays shed light on the cultural landscape in which the featured artists operate and to which their works respond.

The Caribbean Art Initiative extends its appreciation for the support of the Art Council, the program's collaborators from around the world, including like-minded foundations, cultural institutions, and individuals, all of whom have contributed to the creation of an open exchange of ideas around the initiative and without whom the CAI would be much less evolved.

The curators extend their gratitude to María Isabel Rueda and Mario Alberto Llanos, the founders and directors of La Usurpadora, an independent platform for contemporary art, residencies, and curatorial research in Puerto Colombia, Colombia. In 2019, La Usurpadora curated the 16th Salón Regional Caribe, *La Dimensión Desconocida: Otros Relatos del Caribe (The Unknown Dimension: Other Caribbean Stories)*, and a corresponding symposium of the same name directed by Julián Sánchez González. For Jiménez Suriel and Guardiola, participating in these events became the curatorial origin point for this project.

We also wish to thank Lena Kiessler and her team at Hatje Cantz for seeing the value in bringing this publication to a broad art audience and becoming our publishing partner for the project. We are so appreciative of Claire Cichy and Heidrun Zimmermann, who made the book's production process smooth and the end result beautiful.

For translating the exhibition into the form of a visual book, we thank the editor, Alanna Stang, of Well Said, and the designer, Marie Lusa, of Studio Marie Lusa.

Finally, we wish to acknowledge the many curators, artists, partners, associates, authors, and friends who have supported this project.

Previous pages: Ramiro Chaves, *Mapa Manco de Relación (One-Armed Map of Relation)*, 2020, ink on paper

Argentine-born, México City–based Ramiro Chaves (b.1979) is an artist whose practice subverts disciplinary boundaries by creating images and objects through the use of photography, drawing, painting, sculpture, and visual poetry. A frequent collaborator of Puerto Rican arts organization Beta-Local, with which several of the featured artists and curator Pablo Guardiola are involved, Chaves started this drawing as the result of a long conversation he had with artist Diego de la Cruz Gaitán in February 2020 about the behavior of a shoal. He describes his strokes as a venture into a relational narrative around the Caribbean space. "I like to think of that place as a 'cursive space,'" Chaves says. "These lines could be used as a map, but not in the functional retrospective sense of defining routes and, therefore, identities. There are no dots to connect. Their use is more itinerant. A boring, contemplative, and nautical speculation about the future in present time. This map was made with an emotional tone that conveys our conversation about different animals, objects, people, the dead, ghosts, natural and cultural storms, and losses."

A Caribbean Art Initiative Project
Commissioned by Kulturstiftung Basel
H. Geiger, Switzerland

KBH.G
Director: Raphael Suter
Project Managers: Christiane Pohl,
Clarissa Wiese
Photographer: Nicole Strube
Communication: Corinne Laverrière

KBH.G Board
Raphael Suter, Sibylle Piermattei Geiger,
Rocco Piermattei, Dr. Markus Stadlin

Caribbean Art Initiative
Founder and Director: Albertine Kopp
Project Manager: Rebecca Eigen
Communication: Brian Fee
Artistic Advisor: Pablo León de la Barra
Strategic Advisor: András Szántó
Caribbean Art Initiative Art Council:
Pablo León de la Barra, O'Neil Lawrence,
Gabi Ngcobo, Philip Tinari, Sara Hermann

This book is published in conjunction with
the exhibition *One month after being known
in that island* at the Kulturstiftung Basel
H. Geiger, Basel, 2020

Editor: Alanna Stang, Well Said
Project Manager: Claire Cichy, Hatje Cantz
Interviewer: Brian Fee
Copy Editors: Myles McDonnell, Sylvia Metz,
Susanne Philippi
Translators: Aquiles Avalos, John Shelton,
Angelika Thill
Research: Mariana Barrera Pieck

Graphic Design: Studio Marie Lusa
Marie Lusa, Dominique Wyss, Fabienne Wyss
Production: Heidrun Zimmermann, Hatje Cantz
Printing, Binding, and Reproductions:
DZA Druckerei zu Altenburg GmbH, Altenburg

Published by
Hatje Cantz Verlag GmbH
Mommsenstraße 27
10629 Berlin
www.hatjecantz.de
A Ganske Publishing Group Company

ISBN 978-3-7757-4770-7

Printed in Germany

Back cover and spine: Detail of Ramiro
Chaves's *Mapa Manco de Relación
(One-Armed Map of Relation)*, 2020,
ink on paper